Creating Digital Photobooks

Tim Daly

Creating Digital Photobooks

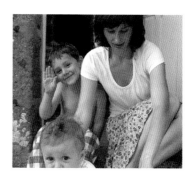

argentum

First published 2008 by Argentum,
an imprint of Aurum Press Ltd,
7 Greenland Street,
London NW1 0ND

Copyright © Tim Daly 2008

The right of Tim Daly to be identified as the author of this work has been asserted by him in accordance with the Copyright, Designs and Patents Act 1988.

All rights reserved. No part of this book may be reproduced or utilised in any form or by any means, electronic or mechanical, including photocopying, recording or by any information storage and retrieval system, without permission in writing from Aurum Press Ltd.

A catalogue record for this book is available from the British Library.

ISBN 978 1 902538 55 6

10 9 8 7 6 5 4 3 2 1
2012 2011 2010 2009 2008

Printed in China

Designed by Nina Daly

Contents

The new way to publish 7

Chapter 1
Printing on-demand 9

Chapter 2
Inspirational themes 26

Chapter 3
Image file preparation 43

Chapter 4
Book design tools 64

Chapter 5
Layout styles 80

Chapter 6
Type and page design 102

Chapter 7
Alternative Styles 120

References and resources 144

Jargon buster 149

Index 153

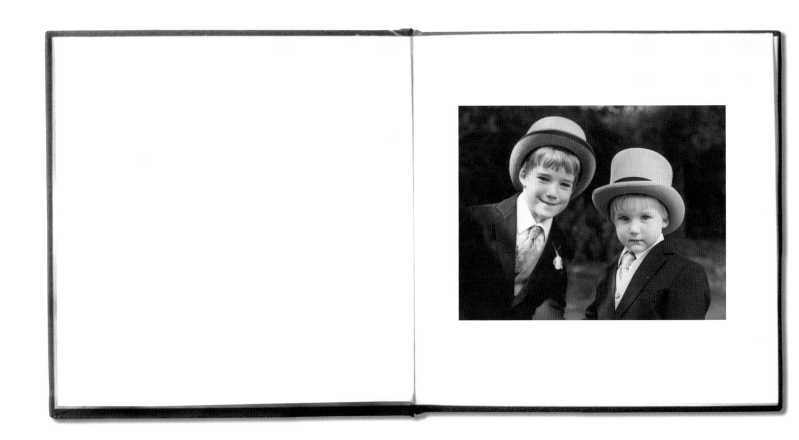

The new way to publish

With the growth of printing on-demand services and the availability of do-it-yourself inkjet book kits, there's never been an easier time to make your own book.

Photography has now entered its third revolution, little more than fifteen years after digital technology changed it forever. Running alongside the development of the photographer's favourite, the desktop inkjet printer, another revolution, this time in the commercial printing industry, has fast been gaining momentum.

The new digital printing press shares much technology with the humble inkjet and, unlike conventional presses, can be configured to print a succession of unique copies rather than several thousand copies of the same document. This capability to cater for short-run, or even single copy jobs, has made possible the growing popularity of the personal photobook.

Taking advantage of this technology, coupled with the development of e-commerce and the growing trend towards buying goods and services online, a number of service providers have seized the opportunity to offer high quality books at low cost, produced without the need to purchase professional design software .

Creating Digital Photobooks maps out these new opportunities and provides inspirational examples of how to present and promote your own work. Illustrated with many books self-published by aspiring young photographers, *Creating Digital Photobooks* examines best- practice production techniques for a wide range of photographic styles and commercial purposes.

The new digital photobook is already becoming the favoured presentation medium for photographers, designers and visual artists. Photobooks, which can be produced with no equipment beyond a desktop computer, are now replacing the clunky portfolio as a sleeker and more professional way to present a proposal or finished project.

For wedding and event photographers, the photobook offers the ultimate way to present a professional record of the day, in a wide range of shapes, sizes and finishes and is fast changing the market for stick-in photo-albums and presentation sleeves.

Visual artists are also seizing upon the opportunity to make professional exhibition catalogues of their work which helps to bring their work to a wider audience and promote sales.

Creating Digital Photobooks provides a comprehensive guide to bringing your publishing project to fruition and shows you how best to display your original images using appropriate styles and layout. It provides advice on image file preparation, choosing service providers and how best to sell your books online to a wider audience; no prior knowledge of book design and production is assumed.

Before digital imaging altered the way we shoot, store and print, many good photographic projects remained unpublished or not exhibited and were filed away forever in a box.

Photobooks now offer everyone the chance to bring much-needed closure to many photographic projects and provide an excellent way of sharing work with family, friends and community groups.

With many commercial and fine art photographers experimenting with this new medium, there's never been a better time to self-publish your work. Suppliers are now producing editions of less than 25 copies, and photobooks are already becoming highly collectable artefacts.

Chapter 1
Printing on-demand

⋯⟩ How printing on-demand works

⋯⟩ Blurb.com

⋯⟩ Lulu.com

⋯⟩ Book formats

⋯⟩ Book covers

⋯⟩ Binding options

⋯⟩ Bespoke books

⋯⟩ How to sell your books

How printing on-demand works

The revolution in photobook publishing has been made possible by the continued improvement in the quality of digital printing presses, particularly the HP Indigo range.

In the early days of digital printing technology, few would have suspected the impact it would make on commercial lithographic printing. Conventional photobooks were typically produced in large print runs, involved expensive reprographic processes and were well beyond the means of most photographers. Nowadays, the introduction of the digital press permits the operator to run off just a single copy.

The digital press is constructed from different modules, each with its own specific function. At the front end of the process is a raster image processor (RIP), equipped with job-management software, which schedules the delivery of different jobs to the press. Within this job-management software are familiar colour-management tools and image-enhancing processes to prepare the document for best quality output. The front end also manages the tricky task of arranging page designs into the correct imposition for double-sided printing and, later, collating and binding on a different device.

The printing engine itself works using an electrophotographic technology and can output several thousand impressions per hour. The typical maximum paper size for presses like the Indigo is 13"x19" and most work on a resolution of 1200 dots per inch (or 300 dpi for each of the four process colours). High spec presses can also work at 2400 dpi.

Workflow

Currently, the dominant press in printing on-demand services is the HP Indigo, shown right. The new Indigo solves the quality problems of early digital presses by using an innovative oil-based ink to avoid the cracking problems associated with presses using dry toner. Latest inksets for the press also employ organic pigments, free from solvents, which are much less prone to conventional fading.

The Indigo press works within the familiar four-colour CMYK mode found in standard lithographic printing, but photographic quality can be improved greatly with the addition of two extra ink modules, light cyan and light magenta, just like a photo-quality desktop inkjet. Quality can be further improved with the use of violet and orange inks.

The implications for a photographer preparing a job for this kind of press are very significant. Compared with the flexible desktop inkjet system, where colour profiles can easily be used to improve print quality, the digital press offers a smaller gamut and less access to colour-management technology for the end-user.

The best option for optimum quality is to carefully colour manage your workflow from shooting, through processing and finally during the preparation of your press- ready document.

Design delivery

Most on-demand providers don't offer a walk-up service, instead opting for fully integrated web-based delivery at the point of order. This offers convenience but comes at the expense of a truly transparent process. For all photographers who are keen to manage colour in the most effective manner, it's essential to contact your printer early and get as much information as possible about their workflow and colour-management procedures and as many tips on file preparation as you can.

In a typical on-demand operation, finished book designs are delivered to the server as a PDF and can go through additional automatic processing before reaching the press. Unlike a typical photographer's workflow, where colour can be managed from start to finish, there can be enormous gaps in the process, critical loopholes that could limit the quality of your final book.

Some of the larger printing on-demand services will route your delivered files to a network of different output devices (some in other countries), making the entire process much less predictable.

If you are preparing design work for an important book production run, it's always a good idea to prepare and print a test book first, so you can see the likely results beforehand.

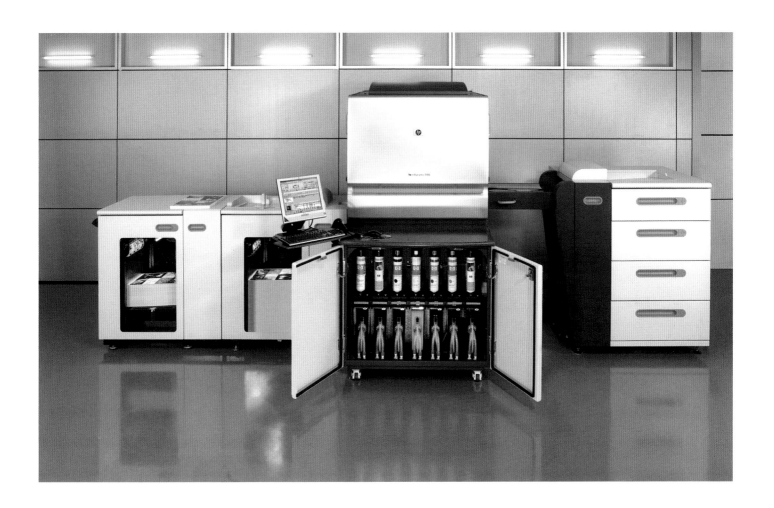

The HP Indigo 5500 digital press, showing individual ink cartridges (in the open cupboard), the large-volume sheet feeder on the right and the finished prints within the unit on the left.

Blurb.com

A market leader in online on-demand book production, Blurb.com also provides an Amazon-like shopfront through which your book can be sold, taking care of shipping and money, too.

One of the better online booksellers and printers, Blurb offers plenty of tools to help you get your project off the ground. Based in the US, Blurb provides a freely downloadable book-design application, BookSmart, so you can lay out your content without any previous design experience. In addition to this, Blurb also offers a freely downloadable e-book with advice on how to plan, prepare and produce your book project. Useful for those who have never made a collection of their work before, the guide lays out the practicalities at each stage.

The book printing service provides plenty of different formats, finishes and sizes of book to choose from, starting with high-volume paperbacks through to high quality hardbacks for special occasions.

Blurb also has an effectively organised shopfront, called the Bookstore, where your books appear once ready for sale. The Bookstore is arranged in different categories, such as Fine Art, Travel and Photography, so your work is placed in the correct section, just as in a real bookstore.

The website also offers tools for users to administer their projects, contact details and royalty payments. As with most other online sellers, you can easily track the number of copies sold by logging into your unique admin area.

Promoting your work

As with any web-based source of information or product, accurate keywording will enable potential purchasers to retrieve your book easily in a search. Blurb provides the opportuntity to add keywords to your book project, so you can link your product to familiar search categories. The trick with keywording is to think laterally about your book, or better still, ask others to think of potential descriptors of your work. The more rounded your keywords are, the more chance your work will be picked up by a casual browser.

In addition to increasing visibilty through keywording, Blurb also offers you the chance to have the first fifteen pages of your book available as a downloadable free preview. The pages are provided in low-resolution format, so there's no need to worry about your image files being re-used without your permission.

This preview section is generated automatically by Blurb's own web mechanics and is created as a universal PDF file. The benefits of providing a preview are plain: potential buyers can see the contents pages, some sample spreads and, of course, the quality of your work. With this in mind, it would be sensible to pack these first fifteen pages with tempting content, so any potential purchaser is left in no doubt about the quality of your book.

The professional B3 service

Fast to take advantage of early anxieties about print quality and colour management, Blurb launched their business-to-business book service called B3. The service provides comprehensive colour-management tools and reprographic advice, enabling professional photographers to exercise the same level of control over book production as they do over desktop output.

In addition to comprehensive advice and technical support, the service also provides ICC profiles, so you can soft-proof and prepare your documents with prior knowledge of their likely appearance. The difference between this advanced service and the standard is just like the difference between a professional photolab and a one-hour photo-processor, but expect to pay a premium for this extra level of control.

B3's initial features include a bespoke colour profile matched to their own presses, offering better colour reproduction and shadow detail, accessible through a new feature called Custom Workflow. To back-up these advanced features, Blurb offers a useful fast turnaround service for those last-minute professional jobs.

Weblink
www.blurb.com

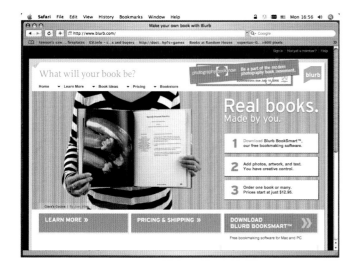

The Blurb website provides a simple interface for creating, previewing and shopping for digital photobooks.

Lulu.com

One of the first on-demand service providers for low-cost publishing, Lulu.com offers free design software and an online shopfront for selling your books to a worldwide audience.

A firm favourite with self-publishers worldwide, Lulu offers a range of services for publishing your book at competitive prices. Both picture and text-only books can be produced and the service is used by many authors publishing on highly specialised subjects not nornally commercially viable within a traditional publishing process. Ideal for first time self-publishers, Lulu provides plenty of online advice on design, file preparation and keeping within their established production restrictions. At the time of writing, Lulu offers plenty of different formats, bindings and finishing options, suitable for producing everything from special one-offs for your own use, to cheaper, high-volume titles for sale. Pages can easily be added to your project as your design grows and there's a simple price calculator that helps to keep track of the overall costs.

Management interface
Most self-publishers are drawn to using Lulu because of the comprehensive tools on offer for organising publishing projects. Once your book is uploaded, you can fully manage the book's presence on the site, adding publicity material, free cover previews and, of course, setting your own sale price. Once you start selling copies of your book, you can log into your private management area and see how much revenue your sales are generating. As with an online bank account, you can manage your funds, decide when and how to receive your royalty payments from Lulu and much more.

PDF workflow
As an alternative to using their own free template software to assemble your book project, Lulu also permits you to create your own design as a PDF. This is an ideal way to work if you would prefer to use a professional layout application like InDesign or QuarkXpress. Final designs for a book must be split into three separate documents: a PDF of the inside pages and two separate image files, one for the front cover and one for the back cover.

e-book and data distribution
Lulu offers an additional file-distribution service, allowing you to upload and sell digital versions of your work direct. Many potential purchasers now prefer to download e-books, especially if they are formatted for use on portable e-book readers.

This kind of service can be useful to any visual artist or designer who has a publishing project that could be offered as an e-book, or who has additional digital resources for sale, such as video clips, image files or specialised plug-ins. Many specialised technical titles are sold as e-books on a chapter-by-chapter basis, so the purchaser can elect to buy only the relevant section, or an update when applicable, rather than the whole volume.

Lulu's data distribution service works in a similar way to online music providers such as iTunes, where access to a digital file is only achieved after passing through an online shopping basket payment system. As with the online book selling service, there are no initial costs in offering digital assets for sale, but Lulu takes a commission on each transaction.

ISBN option
Lulu provides a storefront for selling your books through their own website, but if you want to make your title available through other retailers, then the ISBN option is a good idea. The International Standard Book Number allows your work to be listed and sold through major networks such as Amazon and could really bring your work home to a public, rather than an invited, audience.

Of course, the book can still be produced on-demand, so there's no need to risk ordering a stack of copies before trading begins. The only downside for the purchaser is the longer than normal delay in receiving the goods.

There is a fee for acquiring an ISBN for your publishing project and you have to balance this extra upfront cost against the potential benefits of extra sales.

Lulu.com is a well-established portal for making, selling and buying a wide range of self-published books.

Lulu provides a comprehensive private account area for managing your different publishing projects.

The inside pages of books can be designed using any application, as long as the final submitted file is in the PDF format.

Book cover designs created in Photoshop must submitted as a JPEG file for reproduction on the digital press.

Weblink
www.lulu.com

Book formats

There are a wide range of different book shapes and sizes to choose from, but choosing the right one can be a daunting prospect for a new user.

Different book shapes and sizes usually reflect the function and purpose of the product itself. For example, a typical airport novel is printed in a small format on cheap paper stock, reflecting its short lifespan and the requirement for maximum portability. At the opposite end of the scale, a good quality art book is designed to last several years, casebound and printed on high quality paper to ensure the accurate reproduction of images with sharp detail and rich colours.

On-demand printing provides the same range of options, but offers you the flexibility to try different formats before committing to a final choice.

When choosing a format for your product, you must consider the cost of production in relation to the maximum sale price of your product. Bigger books cost more to produce, but may offer you the chance to squeeze more content in and, ultimately, sell on at a higher price.

When using most template book-design software, it is essential to first edit down your images to fit within your chosen number of pages and budget. However, there is always the flexibility to add more pages during the layout stage, if your project grows larger than first anticipated.

Ideally, the shape of a book's page will provide a complementary border or edge which will enhance yout images. The thing to avoid is a shape that will cramp and suffocate the content.

Book shapes and functions

The most popular choice book for the reproduction of photographs is the horizontal/landscape format. If this has the same proportions as your prints it will allow you to reproduce your work with little cropping and to use a border to separate your image from the edge of the printed page.

Many on-demand bookmakers offer a couple of standard horizontal formats from 9"x6" or 10"x8" to the larger 18"x14" sizes, ideal for landscape-format images but less so for portrait-format images which have to be reduced in size to fit within the depth of the page. It is much less satisfactory to layout a portrait image horizontally, as this requires the entire book to be turned around to view each page, and makes page turning difficult to say the least.

The most universally useful shape for a photobook is the square format, which allows you to layout both portrait-and landscape-format images at the same size as each other on the page. Square-format books can also accomodate symmetrical layouts styles, such as a simple grid of square boxes to show details or enlargements of smaller sections of your work. The square is an ideal shape for an exhibition catalogue, especially if there is a need to accomodate a range of differently shaped images from a number of contributors.

Bespoke shapes and sizes

For special one-off projects such as portfolios and wedding album books, where cost is no object, consider choosing a bespoke service. Large-format books, designed to display larger than normal images have been produced by various private presses for many years, usually printed in small editions aimed at collectors of photography. Produced using conventional lithographic printing, private-press editions are usually priced well beyond the reach of most keen photographers.

A handful of bespoke book producers offer a similar service, using high quality reproduction techniques with large-format inkjets for the printing of the inside pages, rather than a digital press. These high quality books are usually assembled using sewn bindings, and specially finished covers using cloth or vellum can be specified to complete the unique feel of the book.

The advantage of using a bespoke service for a special project is that you can specify a custom size, useful if you've got unusually sized originals to reproduce like a panoramic format, and for special materials for the cover.

Many luxury wedding album manufacturers now offer a complete finished book service for wedding photographers, using luxury materials throughout, but the high unit cost.

A portrait-format book.

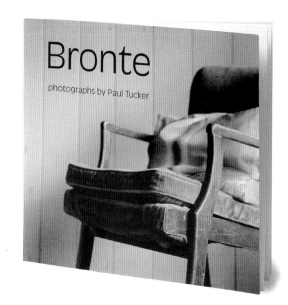

A square-format book.

A mini-format book.

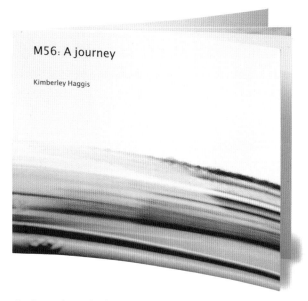

A landscape-format book.

Book covers

On-demand book printers offer several different alternatives for your outer cover, to match both purpose and budget.

Softback books

Easily the cheapest way of having a book made, the softback option can nevertheless result in an attractive end-product. Softback books are made with a single piece of card which is folded and glued to the spine of the book to provide a flexible protective outer cover. The heavier this outer card is, the better job it will do in protecting your precious content.

The quality of softback covers are usually specified by the weight of the card, in grammes per square metre e.g. 200 gsm, or occasionally by the thickness of the media, e.g. 300 microns. With many different types paper and cardboard in use, neither weight or thickness gives a true indication of the rigidity of the material chosen. If you are about to embark on a publishing project it's vital to make a trial version of your book first, so you can test the suitability of your chosen materials. A more expensive version of the softback has flaps which are tucked under the front and rear cover, doubling the strength of thin card covers.

Softback books are very easy to read, allowing you to flex the pages and flick through the contents quickly, but they can easily become dog-eared and turned up at the corners. Not the best option for a book that you hope to sell for a high price, or expect to last.

Hardbacks and dust jackets

Hardback covers are stronger than softcovers and are typically constructed from two rigid boards held together by a single sheet of fabric or strengthened paper. For sizeable books, an additional strip of strengthening material may also be glued into the spine.

Hardback books are more expensive to produce than softbacks, but this extra cost can be passed on to the purchaser who may be willing to pay more for a version which will last longer than a softback.

Ideal for photographic monographs or collections of artists works, hardbacks are offered by on-demand book printers for a small increase in overall cost.

Most hardbacks are available with either plain clothbound covers or with an additional printed dust jacket. Text is rarely printed on cloth covers, instead a dust jacket is used to display the contents, title and author.

Dust jackets are made from a single piece of paper which is printed on one side only. This is folded round the book's spine and also at the leading edges of both front and rear covers to create two tucked under flaps. These two flaps can also hold additional text or images, and are frequently used to provide a brief synopsis of the book and details of the author.

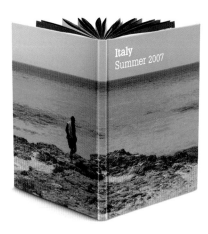

Cover coating options

For an additional fee, some providers offer enhanced covers printed with transparent varnish or laminated with a thin film of plastic. These protective coatings are typically available in high gloss, semi-matt or a waxy finish and will enrich the colours in the printed cover in the same way as the use of glossy inkjet papers.

In addition to making your cover look more luxurious, these coatings also provide a little extra protection against excessive wear and tear and the fading of colours caused by exposure to UV radiation.

In the digital on-demand printing process, the book cover is rarely printed on the same press as the inside pages; which is why a book project is prepared as two or more separate documents.

Rigid covers

Self-binding systems such as self-assembly inkjet post-books and the Unibind range, are usually based on rigid, plain covers. Although most can't really be personalised as a dust jacket design can, some have a pre-cut aperture to allow an underlying print to show through.

For many users, the convenience and cost factors are outweighed by the unmistakeable 'album' feel of the finished product.

A rigid cover book clamps the pages together, making it difficult to fully open out.

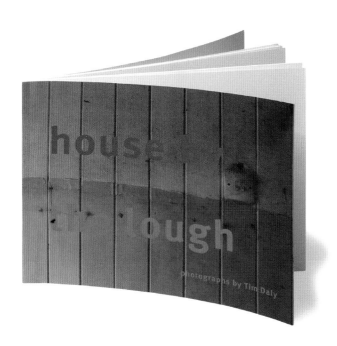

A softback book is flexible and easy to read, albeit with the risk of becoming detached from its binding.

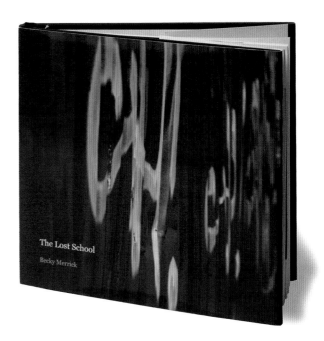

A hardback book with a wrap-around dust cover offers a more durable option.

Binding options

Books can be assembled and held together using a variety of different binding techniques, some more durable than others, and to fit a number of different purposes.

Post and spiral binding

The cheapest method of holding the different components of a book together is to spiral bind it. The resulting product looks less like a conventional book than an office document. Spiral-bound options are offered by many on-demand book printers, using wire or heavy plastic comb-type binders. Spiral-bound books work best if they have at least one thick backing board as part of the cover, otherwise they become floppy and difficult to handle. With the spiral comb taking place of the spine, the finished product is not easy to navigate and pages can easily become detached from the binder.

However, for a technical manual or a book with little content worth reflecting on, the spiral can be a cheap and effective way to cut your production costs.

Post-bound books also offer a cheap and cheerful option, usually in the form of a print-it-yourself kit. Based on the kind of photo album popular in the 1950s, the materials for post-bound books are supplied in pre-punched single sheets which are then printed through a desktop inkjet. When dry, the sheets can be assembled in the right order, then slotted over two posts fixed to an outer hard cover. Although convenient, as you can keep changing the contents by unscrewing the posts, these books do not open out with the same ease as a sewn book and should not be used for displaying images on facing pages.

Perfect binding and adhesives

At the cheaper end of the production scale, books can be bound with an adhesive strip, in a process called perfect binding. In this process, several inside pages are printed together on a large sheet of paper, which is then folded and cut. After assembling in the correct order, the spine edge of the book is milled to provide a key for the adhesive which holds the block together and allows the cover to be attached.

All paperbacks are perfect bound, so that opening them out flat inevitably involves creasing the spine. Traditionally, books bound in this way were not expected to last more than a few years before single pages or even clumps of pages started to fall out. However, with advances in modern adhesives, perfect binding is an acceptable way of finishing smaller scale books like exhibition catalogues.

Machine sewn and stapling

The most permanent of all bindings is made when pages are printed on large sheets which are then folded into signatures, before being stitched together. The result is very durable and also allows the book to be opened out to fully appreciate a double-page spread. Sewn bindings are the best way to assemble a large book, providing support for the individual sections and allowing the use of heavyweight papers.

An alternative to the sewn binding is the inexpensive staple binding. Although only possible with single-section books with a fixed thickness, staple binding is cost-effective and extremely durable, too.

Guillotine restrictions

Almost all commercially produced books are trimmed at the final stage to remove ragged or misaligned edges. This operation is carried out with an automated guillotine, which can impose some limitations on your layout. If you wish to bleed artwork (i.e. print it right up to the edge of the page) most on-demand book producers advise extending it beyond the edge of your page by at least 3mm, to allow for an acceptable margin of error and to remove the risk of a thin white line appearing on the edge of your page. It's never advisable to place important detail, either text or images too near the edge as it could be chopped off.

A clamped-spine book from HP

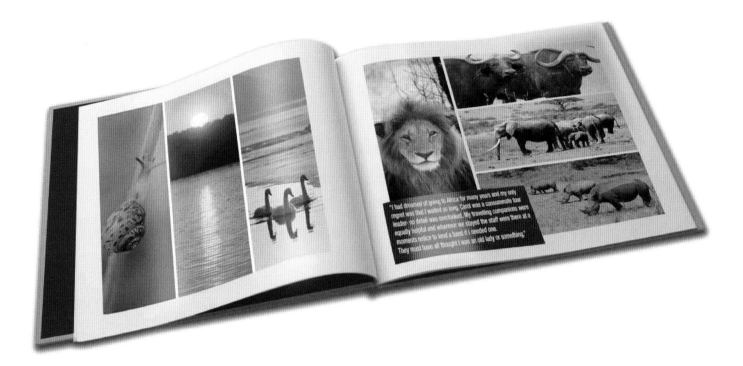

Unibind hot glue system

A recent innovation in perfect binding is a hot glue system from Unibind. In this do-it-yourself process, special glue-impregnated covers are used to wrap around the inner pages. The completed book is then placed in a special desktop heating device which turns the glue into a liquid form, so it binds the individual pages together. Although convenient and capable of producing professional looking results, the system has drawbacks in the form of the high cost of the equipment and the limited range of covers available.

The Unibind heating device

Bespoke books

An alternative to the mass-produced products available from on-demand printers, the bespoke book is hand-made and produced in very small editions.

Since 2003, it has emerged that the great American colour photographer Stephen Shore has been making unique books of his work using the simple iPhoto application. Unlike many other photographers, who have been publishing essentially archive work, Shore has used the short-run book as a totally new medium to express his ideas.

Many historic photobooks are housed in the UK at the National Art Library. There, as in the Print Room at the Victoria & Albert Museum, rare books and artefacts can be examined by researchers and postgraduate students. Many nineteenth-century books were created using actual photographic prints, tipped in, and looking more like a scholarly album than a mass-produced work. Made before the successful development of halftone printing to reproduce the delicate tones of a photographic image, the early photobooks have now become increasingly sought after by collectors.

Alongside the popular print-on-demand suppliers such as Blurb and Lulu, a growing number of more specialised services have developed which print and hand-bind inkjet books in very small runs. Effectively a private press and artist's print studio combined, they offer top-of-the-range finishes and tailor-made solutions for very discerning clients.

Aimed at the same collector's market that would be attracted by a portfolio of prints,

A cloth-covered hand-made book.

the short-run hand-made book will in the future become the most sought after kind of photobook. Mindful of the rising popularity of book-making and the increasing permanence of inks, many paper manufacturers now supply double-sided cotton papers which can easily be printed, folded and stitched into sections ready for binding.

The practice of binding books by hand does not require much in the way of specialised equipment, except for a heavy object or bookbinding press to keep the project flat during construction. Unlike the fast turnaround acheived when using on-demand printing services, making books by hand is a lengthy but rewarding process. As the term suggests, bespoke books can be made with top quality materials inside and out.

Booksmart Studio

This is an innovative US-based company that offers a kind of private press service for exclusive short-run books. Using a range of inkjet output devices together with traditional hand-binding techniques, Booksmart Studio prides itself on working with each individual artist to create a unique edition.

Like other similar services, Booksmart Studio offers a full design service, plus a very hands-on approach to meeting the high expectations of their clients. You can arrange to see sample proof books, before you commit to the final run and a wide variety of finishes including cloth covers, slipcases and foil embossing are available. Prices start at around $750 including design, proofs, printing and hand-binding.

Website:
www.booksmartstudio.com

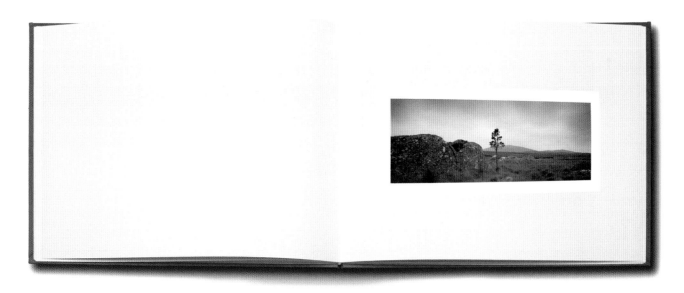

A unique hand-bound book of inkjet prints made by the author.

Alternative formats

The advantage of pursuing the bespoke route is the infinite range of sizes, shapes, covers and containers available. The bespoke book is an ideal way of presenting your work – the equivalent of a hand-made portfolio that will surely impress potential clients. Not restricted by the limits of the digital press, hand-made inkjet books can be produced in any shape or size to suit the nature of your work.

Slip cases are an ideal way to give your book additional protection at a relatively small extra cost.

Even better protection is afforded by a box, either a clamshell type, or a fold-up type, as shown on the right. These containers exclude harmful UV light, which will bleach the colours from your book's spine in no time at all, even in a slipcase.

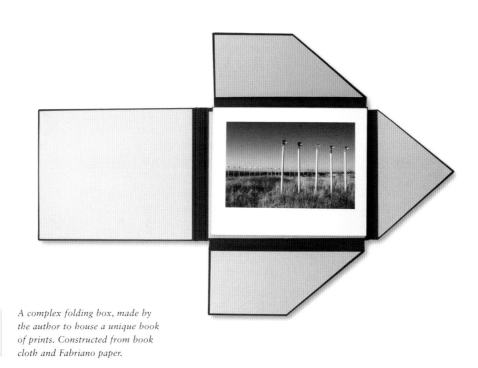

A complex folding box, made by the author to house a unique book of prints. Constructed from book cloth and Fabriano paper.

How to sell your books

Online service providers also enable you to sell your wares to a worldwide audience, usually without risking any financial outlay, but you need to work out your profit margin carefully.

Production costs

The simplest way of setting the price for your product is to start off by working out the production costs for each book. All on-demand providers publish fixed costs for books depending on their format size and binding, cover type and number of pages (extent). Most providers have a fee structure for books produced within a set page range, typically 1-40 pages, 41-80 and above. The price scales relate to the additional costs of binding or the use of a further sheet of paper in the press, when the size of a book jumps from one band to another. There's little sense in making a 41-page book if this adds an extra 20% to the production cost for the addition of a single page, so you need to carefully consider the implications of extending your project into a higher price band. Some providers price their books by the page, a more flexible arrangement, but one which makes it is easy to overlook the cumulative costs.

Setting the retail price

The beauty of using e-commerce to distribute and sell your books is that you can set the price to match the demand. Start by working out your production costs first and then work out how much you could sell the book for. Deduct from this the percentage taken in commission by the provider and you can work out how much profit you can make on each individual sale.

Currency and banking charges

In addition to the small commission charged by your service provider for each sale through their website, there can be other hidden costs to bear in mind. Most international e-commerce sites naturally encourage participation by users from a wide range of different countries using different currencies, but this convenience comes at a cost.

Online bookselling services will have a number of different options for paying you royalties after each sale, either by electronic transfer to a PayPal account or by cheque in the currency of origin. Your profits are usually rounded up on a monthly basis, but you can usually elect when to receive your payments. Before launching a project through an e-commerce site, work out how much you will pay for a currency transfer or a PayPal transfer to your account. Many banks have a set fee for processing a payment in foreign currency, regardless of the amount received, so it may be more economic to make one larger transfer every few months, rather than a monthly one.

Selling direct

An alternative to using an e-commerce facility is to take control of distribution yourself. Although this will take up more of your time in managing orders, posting books off and cashing income, your profit may be higher than you think. Many service providers will offer a discount if you are confident enough to buy a quantity of books upfront, typically 25 or more, enabling you to make more profit per sale. Taking control of selling your book is ideal if you have ready access to your market, such as selling an exhibition catalogue during an exhibition itself, or any other event where you meet customers face-to-face.

If you decide to sell your books directly by mail order, it's essential to order up a sample version of your book first, so you can work out the cost of shipping which will vary according to size and weight and the cost of packing materials.

Beating the order delays

For the purchaser of an on-demand product, the prospect of an uncertain delay between ordering and arrival can be a demotivating factor compared to buying a ready printed book from Amazon. By taking control of the distribution yourself, you can solve this problem, albeit at the cost of the increased financial risk involved in buying stock upfront.

e-books

The simplest e-book version of your publishing project could be the very file you submitted to your service provider for making your book. Most freely available template software distributed for designing on-demand books saves the final press-ready file in the universal Portable Document Format, known simply as PDF.

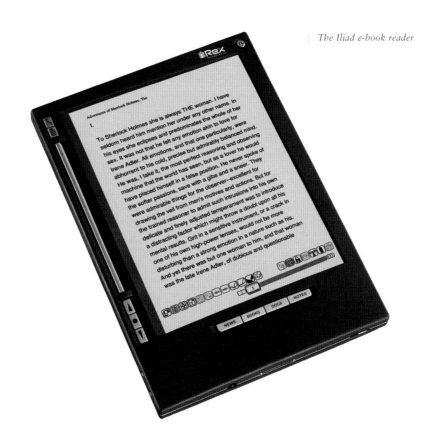

The Iliad e-book reader

e-Book readers

At its most basic, the humble home PC is the simplest of all e-book readers, but it's hardly portable. In addition to laptops, there are now many portable e-book reading devices that are targetted specifically at publications with technical content, where portability is an advantage. Most early readers, like the example shown right, only offer a monochrome display.

Phased release

An alternative method of planning a publishing project is to use the convenience of e-book distribution to release smaller chunks of a book, much like conventional partwork publishing. For specialist knowledge-based works or technical manuals, a monthly issue may be more relevant than a single, bigger volume which could quickly become out of date.

Pick and mix

With on-demand publishing it's also simple to arrange for different versions of a single book, too. Put simply, a potential purchaser could customise the content of a book if you offered them the chance to select relevant chapters from a larger list, on a pick-and-mix basis.

Updating your content

If your publishing project contains time-specific information or images, it's much better to separate this into chunks, making for a much easier update later on. Potential purchasers might be tempted back to buy the update, too.

Keeping books in print online

Selling PDFs of a short, or sold-out print run is also a good way of keeping your content available to a new audience without needing to risk another financial outlay. For many community and publicly-funded arts organisations, like the London Independent Photography group, generating an e-version of a book, journal or magazine can provide a low-cost way of keeping the back catalogue still available.

Chapter 2
Inspirational themes

---> Land and light

---> Time-limited projects

---> 'Late photography'

---> Urban spaces

---> Exhibition catalogue

---> Independent travel

---> Portfolio book

Land and light

Many of the world's greatest photobooks have been created around a landscape theme. From far-flung locations to simple records of the passage of light, the landscape is a worthy starting point.

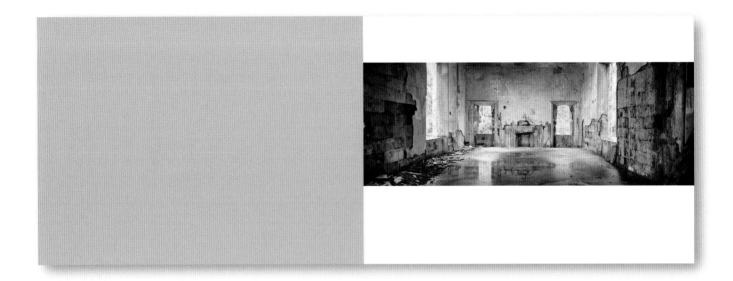

Project ideas

Despite the many extravagent locations immortalised by the world's leading photographers, you can really shoot a landscape project anywhere you like.

Research is always the key to all good photo projects and coastal locations are worth investigating, especially if there are historic remains or a unusual terrain to capture, ideal if you want to go beyond the purely pictorial

Many photographers have examined the impact of man on the environment, a broad theme that can couple a landscape study with another underpinning concern, such as industrialisation, environmental issues or political undercurrents.

Layout essentials

When shooting a landscape project, careful in-camera composition and hand-crafted printing technique will pay dividends. Therefore it's important to preserve your hard work with a sensitive layout style.

Always place plenty of blank space around each image and display only one image per double-page spread. Don't crop your image unless it will really improve the overall composition. Keep your captions functional, brief and at a size that doesn't attract attention. Finally, sample a midtone colour from your image and use this to tint the opposite page, to enhance your images, as shown above and right.

Inspirational photographers

If you're keen to look at classic examples of landscape photobooks, then the following photographers are well worth investigating.

John Blakemore is best known for his way of recording the land through an unusual exposure technique. Rather than taking a single shot, he overlays multiple exposures in-camera to create a mixture of movement and sharp focus.

John Davies' work examines many different issues: the impact of our industrial past on the landscape and how contemporary landscape architecture is shaping the world today. Known for his exceptional attention to framing and clever viewpoints.

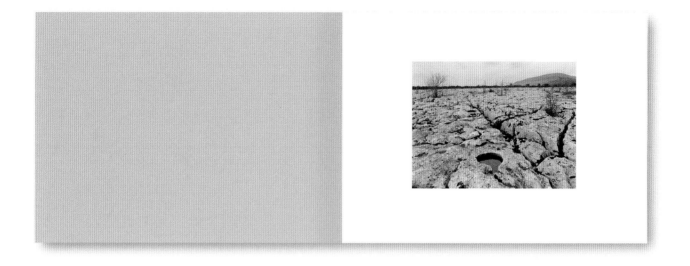

The Burren, Ireland.

Time-limited projects

Many of the most inspiring photobooks are created under self-imposed time constraints, providing much-needed structure and the discipline of a fixed end-point.

Project ideas

Many photobooks are shot within a specific time-frame, to provide the project with an extra, underlying structure.

Concepts such as a day in the life, a year of Sundays, 24 hours, the first 100 days of the president's tenure, your newborn child's first year, all provide a useful backbone for a photo-documentary and photobook.

Basing a project on a season is a good way to record a garden or the changing landscape, like a creative time-lapse. Repeatedly shooting from the same viewpoint could also produce rich pickings.

Layout essentials

Tie the extent and layout of your book to your underlying concept. Your time-based idea will naturally suggest a number, so to present a year of Sundays, choose 52 pages for your book.

By imposing a shooting and layout restriction from the outset, you will be forced to focus carefully on including only the very best images.

The alternative is to choose a very large number instead and create a kind of visual blog book, where hundreds of smaller images are used together, perhaps unedited.

Transient subjects

Making a photobook out of a project really helps to capture the essence of a here-today-gone-tomorrow subject.

Many keen gardeners make photobooks of their plots, to capture the different seasons, changing growth and the flowering habits of their prized specimens.

Printed and bound as a creative record of the year, the garden diary photobook is also an excellent gift for non-photographer gardeners. If you plan to start such a project off, look at some templates beforehand, so that you have an idea of the size and shape of picture boxes in mind when you start.

Glenveagh House

Oulton Cottage

'Late photography'

Using an almost forensic approach to documenting the past, this reflective way of working is ideally suited to the photobook form.

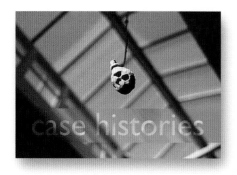

Project ideas

The term 'late photography', first coined by David Campany, has gained popularity recently as an insightful way to describe the practice of reflective documentation.

Unlike a photo-journalist, who seeks to record events as they happen, the late photographer is concerned with piecing together a story from the fragmentary evidence that remains once it has passed into history.

Of course, many photographers have worked in this way before. The practice of telling a visual story by using the scraps left behind can produce intriguing results and a more reflective interpretation. A good idea is to avoid the obvious, dig deeper and closer to find more evocative ways of telling your chosen story. Collect as much visual material as you can before starting to edit it into a book format.

Layout essentials

With this kind of photographic project, the success will lie entirely in the editing. After shooting and collecting your material, you need to start grouping images together like a detective recreating a crime scene.

The sequence in which you present your images is critical. Each image that you choose will contribute to the story you are telling. Avoid multi-panel layouts, where too many different images are presented at the same time. Instead, pace your material carefully through the book, using a mixture of details, close-ups and scene-setters to gradually build up a broader picture.

Keep your layout style clean and uncluttered, avoiding any page furniture like borders, rules and even captions. Don't dictate how the story is to be interpreted with your own words, leave that to your readers.

Case Histories

The author's own documentary project, shown above and right, was conceived to investigate and examine what was left when a large-scale asylum complex in the UK was abandoned.

The project records a wide variety of scraps, objects and places, from a location now deserted. Presented together in book form, these unconnected items are packed with symbolic meanings.

Fragments of hand-written notes, personal possessions, medical records, clothing and ephemera were all recorded and are presented almost as a catalogue, without captions or commentary.

Weblink

www.blurb.com/user/timdaly

Urban spaces

A creative way to capture the visual qualities of an urban space is to shoot it in atmospheric black and white. Like a sooty charcoal drawing, black and white can be much more expressive than colour.

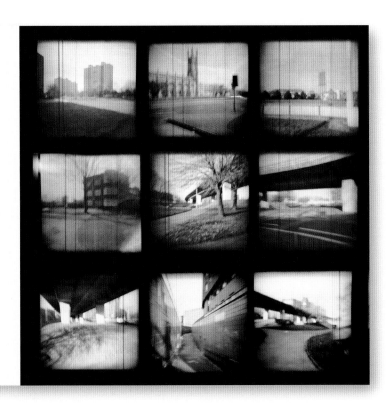

Black and white film style

A by-product of the success of digital photography has been the loss of black and white film style: that gritty, grainy way of making hand-finished prints in the darkroom.

However, great black and white images can still be made, either by converting RGB to Greyscale in Photoshop or, even better, shooting real film and scanning.

Low-tech cameras

Shot on a plastic Holga camera, the set of images above capture the urban chaos of Manchester's Mancunian Way.

The Holga takes 120 roll film in either 6x6 or 6x6.45 format and can be used to produce surreal pictures with a creeping black vignette at the corners. Atmospheric, low-tech, unpredictable, it's everything a digital SLR isn't.

Contact print layout

One way of designing a photobook like this is to use a contact print layout, as shown above. Either scan your film on a large flatbed scanner, capable of ultra-high resolution capture, or arrange your images as one single file. With a grid of 3x3, you effectively make a layout within a layout and can create interesting juxtapositions between different images on the page.

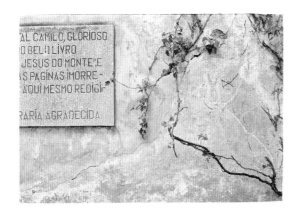

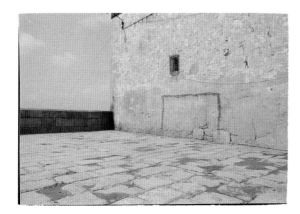

Project ideas

Shooting an urban space is a great way of discovering how different clans, cities and cultures work. It's as if the very fabric of the environment describes and defines the inhabitants, their history and immediate future.

Urban space is where all the big subjects collide: people, buildings, crime, money, social issues and politics.

Photographers to look at

Several renowned photographers have explored this theme, including *Eugene Atget, Lee Friedlander* and *Stephen Shore*. All three work to untangle the complex ingredients of a public space, each making exquisite renderings in very different styles.

Perhaps the best photobooks ever made is *The Americans* by Robert Frank, a chronicle of the changing USA in the 1950s.

Classic reportage layout

The author's own documentary project shown above, was shot in northern Portugal.

Using a portrait-format photobook, each 24x36mm negative could be reproduced on the page without cropping.

Weblink

www.blurb.com/user/timdaly

Exhibition catalogue

The low cost and high quality of the digital press provides professional artists and photographers with an economical means of producing exhibition catalogues to sell their work and build their reputations.

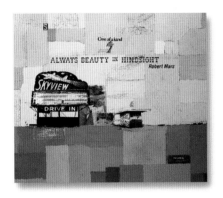

The exhibition catalogue

The humble catalogue serves many purposes, beyond simply illustrating a set of pictures on a wall.

Before the advent of digital photobooks good quality catalogues were well beyond the means of most artists and independent photographers.

Nowadays, it's possible to make 25 simple catalogues for around £100, money which you'll easily make back by selling them on at your show's private view.

Although the catalogue's primary function is to present work for sale, it also works as an effective marketing tool.

It is ideal for sending to prospective clients and curators, and will help to ensure that your current project has a long life span and stays in the public eye.

Layout essentials

The most important aspect of a catalogue is ensuring the colour accuracy of your work. Spend time getting the soft-proofed colours on your monitor to look as close as possible to your artwork. When doing this, it's an advantage to have your work, either print or painting, to hand, so a direct comparison can be made.

A clear and well conceived artist's statement at the beginning is essential. Always have your text read in proof by a non- specialist, so you can be sure it makes sense!

Keep your captions functional, listing title, dimensions and medium and ensure that this information is set unobtrusively on the page. A single page with thumbnails of each piece (as often seen in clothes catalogues) is a great way of finishing off.

Robert Mars

Fine examples of exhibition catalogues, shown above and right, were designed and produced by US artist Robert Mars using the Blurb self-publishing service.

In his projects *Lost Vegas* and *Always Beauty in Hindsight*, Mars chronicles the soon-to-be-lost American highways, mixing collaged symbols and signs with layers of paint to create unique pieces of work.

With a subtle use of type and layout, Mars' books convey his extraordinary use of colour and collage and show his work off to the full. Each spread is carefully planned to allow one or two pieces of work to be displayed, without vying with each other for your attention.

Weblink
www.blurb.com/user/marsrob

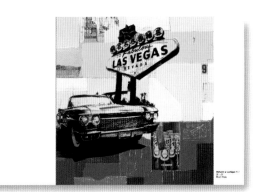

LOST VEGAS

Welcome to Las Vegas 2007
36 x 36
Mixed Media

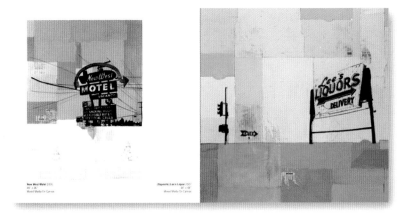

New West Motel 2005
48 x 36
Mixed Media On Canvas

(Opposite) Lee's Liquor 2007
48 x 48
Mixed Media On Canvas

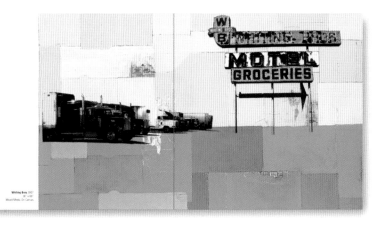

Whiting Bros 2007
36 x 96
Mixed Media On Canvas

Independent travel

Avoiding the obvious places and well-trodden tourist routes, the independent travel project makes a great idea for a photobook.

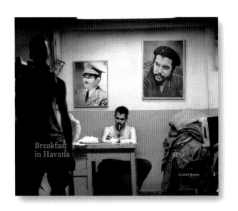

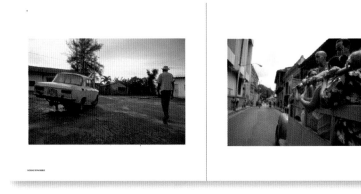

Project ideas

Travel photography is about recording how you interact when transposed to a different culture, rather than just snapping random photo opportunities. The very best travel projects are made when proper research is done before the visit and plenty of time is spent exploring off the beaten track.

What you find, the journey getting there, the gems that you uncover and the glimpses of people you've never met before, all mixed up together, make for a great photobook. The perfect way to encapsulate your experiences for sharing with friends and family.

The book itself can take many different forms: a day-by-day journal, a collection of found situations, a road-movie through the landscape or even a catalogue of people, types or things.

Layout essentials

Travel projects, by their very nature, are long and produce an enormous quantity of images and many unexpected results. If you have the good sense to plan your book beforehand, look at some layouts before you go and devise a shooting list to fit.

On returning, the all-important first step is to make a careful edit of your source material, grouping it together in a number of ways: chronological, by place or by subject, as this will help you devise a running order for your book.

Try to rate each image, too, deciding which are good enough to occupy a page on their own, and which provide mere 'texture'. The latter kind work best when combined with others on the page, or reproduced smaller.

Andrei Rozen

To document the time he spent in Cuba, photographer Andrei Rozen has produced an intriguing book called *Breakfast in Havana*, shown above and right, skilfully capturing a slice of real life.

Not standing back from the action, the book describes the way Rozen got involved, seeking out the textures and colours of life on the street.

The book is also exceptionally well laid out, with two images per double page spread. Notice how well matched each pair of images are and the way lines and shapes within each image are directed to the centre of the spread, a good technique for holding attention.

Weblink

www.blurb.com/user/andreirozen

TRINIDAD SINGERS

CONGO BOY

SANTIAGO

PA' MI PUEBLO

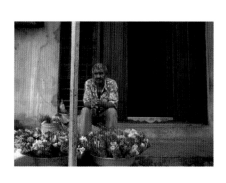

THE FLOWER MAN

UN HOMBRE EN LA PUERTA

Portfolio book

The days of lugging a heavy black portfolio case to client meetings is over. A much smarter idea is to produce a book of your best work.

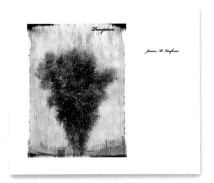

Project ideas

Putting together a portfolio of your finest work is a difficult task at the best of times. Juggling with differently sized prints or artwork, buying expensive sleeves and finally, a case so heavy that it's likely to maim a small child if dropped. Old-style portfolios were often made-up for a single interview, an expensive way to get your message across.

By making a photobook, however, you are immediately able to do two things you couldn't do before: leave it with the client forever (should you wish) and update the contents at no cost, beyond the price of a reprint.

A good portfolio book should be a mixture of 'greatest hits' and newer, edgy work, arranged in such a way as to suggest that you're a creative thinker.

Layout essentials

If your artwork is digital to start with, then the whole process is much easier from start to finish. If your work is in print or other form, then it's essential to spend a proper amount of time making colour-corrected scans.

There are several different ways of making a portfolio book, but the best way is to make it resemble a museum box of fine art prints.

Arrange your images with generous white borders and don't over-enlarge them to fit the page.

Carefully sequence your work and don't put your strongest piece on page one. Instead, try and punctuate the running order with suprises, this will help to keep your reader intrigued.

Jessica Kaufman: *Panopticon*

A unique book of images, so simple in their capture but somewhat haunting in their creative treatment.

Each monochrome image is presented behind a kind of chemically induced veil, using the accidental by-products of film processing, peel-apart film material and a fine sense of darkroom printing.

A great example of how to present your personal style to any prospective interested party, be it curator or client, *Panopticon* is arranged without fuss or clutter, allowing you to focus solely on the work within.

Weblink

www.blurb.com/user/Jisk

Chapter 3
Image file preparation

┄┄⟩ Photo reproduction

┄┄⟩ Colour space essentials

┄┄⟩ Colour space workflow

┄┄⟩ Soft-proofing your images

┄┄⟩ Non-destructive editing

┄┄⟩ Online editing and preparation

┄┄⟩ Contrast adjustment

┄┄⟩ Colour adjustment

┄┄⟩ Special black and white

┄┄⟩ Resizing and resolution

Photo reproduction

Preparing a book design for digital press output is similar to packaging files for commercial lithographic printing, but with more predicatble results.

Colour reproduction

Preparing output for a digital press is much more problematic than using a desktop inkjet. In the absence of access to the colour-management process, you need to plan carefully to ensure that your colours turn out as you intend.

The most important difference between the final image reproduced in your book and what you see on the screen centres on the smaller colour gamut of the press. Images reproduced on the digital press using the four standard process colours of Cyan, Magenta, Yellow and Black, can be less saturated than an equivalent print made on a six, or seven, colour inkjet printing device.

Traditional colour trade-offs have seen vivid blues and purples reproduce on press much less saturated than desired, when compared to what appears on your desktop monitor.

To prepare for this eventuality, it's essential to soft-proof your images before inserting them into your layout application. Soft-proofing is Adobe Photoshop's way of displaying on your desktop monitor a simulation of the way your image will appear when printed with a specific press, paper and ink combination.

Photoshop can only achieve this by referencing an ICC profile, which is supplied by better service providers such as Blurb in their professional B3 service.

How tone is reproduced

In traditional commercial litho printing the subtle tones found within a photographic image are reproduced by tiny dots of printing ink of varying sizes. This dot screen is an optical illusion, which tries to mimic the continuous tone of a photograph without separating into areas of flat colour.

In practice, there are many different kinds of screening patterns and dot sizes, both designed for use with specific printing papers, but the finer screens produce the most 'photographic' results. Screen resolution for digital/litho printing is defined in the terms of lines per inch (lpi) whereas inkjet printers are rated by the number of ink droplets (dpi) sprayed onto printing paper.

For digital printing the resolution is normally between 150 and 180 lpi. Since digital printing requires two pixels to be provided for every printed dot, a screened image will typically have a resolution of 300 pixels per inch (ppi).

In broad terms, coarse uncoated printing papers such as newsprint can only cope with larger dots, but smoother coated printed papers, as found in art books, can hold the finest of dots in place. The absorbency of the printing paper itself, determines if the dot of ink will remain a discreet size, or if it will spread into a slightly bigger shape than intended, a phenomenon called dot gain. This common problem is largely eliminated on the digital press by processing software.

Pantones and duotones

For those photographers making complex black and white images in Photoshop using the duo- tri- or quadtone function, it's important to be aware of the reproduction limitations before starting to prepare files.

Many of the most luxurious photographic books produced by leading publishers such as Aperture and Steidl employ a carefully tested custom inkset, using Pantone colours, which has been designed to match the colour of the photographer's original print as closely as possible, rather than the CMYK set. The delicate tones of vintage silver gelatin prints, perhaps developed in warm-tone chemistry, would not reproduce accurately with standard CMYK.

Within the CMYK gamut only 40-50% of the 1000 or so Pantone colours can be reproduced within an acceptable visual limit, but this is improved to 80% if your printer uses the additional violet and orange inks set known as Indichrome (or CMYK OV), plus an additional green.

If you have access to an Indigo press printer who can offer you this additional service, it will come at an extra price, but may allow you to reproduce a very specific effect, especially if you are trying to reproduce the look of a vintage black and white photographic paper.

When viewed on screen, RGB mode images display vivid blues that may not translate to the printing press.

The same image shown in Photoshop, but using the soft-proofing functions to mimic the likely effect of CMYK printing on the digital press.

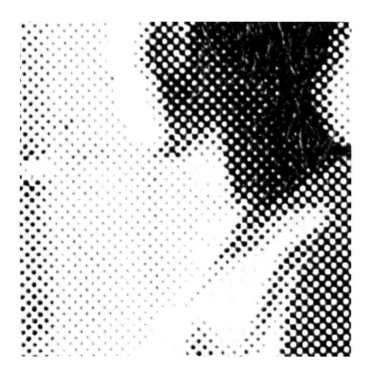

A close-up of a black-ink only litho reproduction, showing the way different tones are created by differently sized dots.

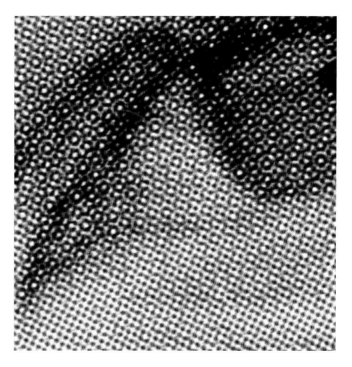

This example shows a close-up of the dot screen produced by an Indigo digital press. Notice the rosette pattern creted by the different ink colours.

Colour space essentials

The management and delivery of accurate colour is at the top of every photographer's wish list, but how this is achieved can seem very complex.

Display RGB and printing CMYK

The fundamental issue at the centre of reprographic technology is the incompatibility of two very different systems in common use. Coloured light transmitted by a desktop monitor is different to coloured light reflected from printing inks on paper. Both systems employ unique technology for reproducing colour in a fixed, characteristic range, called a gamut. The range of reproducible colours available for a printed out photographic image will always be smaller than the range that can be displayed on a monitor.

In digital reprographics, the different colour ranges produced by RGB and CMYK technologies are referred to as working, or colour spaces.

What is a colour space?

A more understandable term for colour space is colour palette. In today's digital world there are three commonly used colour spaces: sRGB, Adobe RGB (1998) and ProPhoto. sRGB has the smallest palette, ProPhoto the largest and Adobe (1998) is the most commonly used by photo professionals.

Yet, although each individual colour in a digital image drawn from a palette of 16.7 million variations is determined by a unique string of numbers, the same numbers may not produce the same colour when translated across different colour spaces.

Colour management is the term we use to describe how best to control the way colour is translated from one space to another. Done badly, it ensures that you will experience unexpected results; but with proper management, you can edit out unwanted translations and fully preview the end result, before committing to output.

Practical issues

Most practical problems occur when an image created in a larger colour space, such as Adobe RGB (1998), is forced into a smaller colour space, such as sRGB. The resulting image is mapped across to the new palette, but with some compromises occurring invisibly in the background. Before any image editing takes place, it's essential to have your workflow mapped out, so you can avoid these pitfalls of poor colour management, thereby ensuring your images are prepared properly and reproduced at top quality. The first step in the process is to find out as much about your chosen book printer as possible, including how they like to receive files.

Secondly, find out if there are any freely downloadable profiles for their chosen printing press so you can preview the likely results through Photoshop's soft-proofing functions.

The large Adobe RGB (1998) colour space.

The smaller sRGB colour space.

Blurb's digital press CMYK space, as used in its professional B3 service.

A desktop preview of an RGB colour image, viewed without using Photoshop's soft-proofing functions.

The same file viewed in Photoshop, but under custom proof conditions, matched to an HP Indigo 5000 press. Notice the very different colour reproduction.

An unconverted Nikon Adobe (1998) RGB

Nikon Adobe (1998) RGB converted into the smaller sRGB workspace. Notice the slight change in the colours of the sky and leaves.

Colour space workflow

With the emergence of professional book production services, such as Blurb's B3, it is now possible to fully colour manage your project from shooting to pre-press.

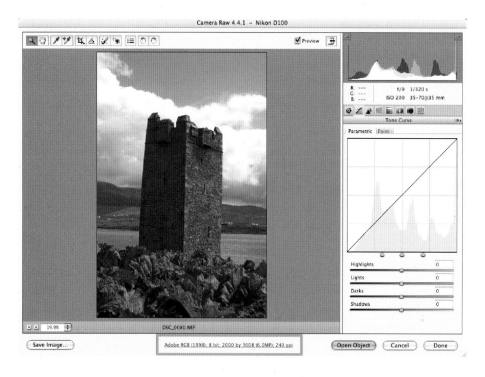

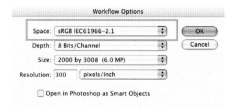

Using the sRGB colour space

All of the major photobook service providers recommend the use of the sRGB colour space when preparing images for the digital press. The reason for this is simple: the smaller sRGB colour space is closer in extent to the CMYK space used by the press, so there will be fewer differences between the onscreen and printed versions of your image. It's essential to get your files into this space before any image editing takes place, or your results will be unpredictable.

Best option: shoot RAW files

The best workflow decision is to shoot in the RAW file format. Unlike the TIFF and JPEG file formats available in your camera settings menu, which are all created with a colour space tag, RAW files are untagged at the point of capture.

Instead of an embedded tag that defines how the the file will be interpreted later on in Photoshop, a specific colour space is assigned to the RAW file in the Camera Raw plug-in or other RAW file processor used.

Although the RAW file is not tagged with the colour space set on the camera at the point of shooting, this information is recorded in the file's EXIF data, which transports other camera settings to applications like Bridge. However, you are not restricted to embedding the file's transported colour space tag, you can easily assign a different one.

In the Camera Raw plug-in, locate the single line of text that sits immediately underneath the image window, the single sentence which contains the description of the colour space, image resolution and file size, as shown left in the blue box.

Next, click on this line to bring up the Workflow dialog, as shown above. Click into the top pop-up menu called Space and choose the sRGB option, you will see the ProPhoto and Adobe RGB (1998) options there too. You can also set the resolution of the file to 300 ppi at this stage, saving you the task later on.

This is the most versatile scenario available, as it allows you to shoot as normal, with book, web and inkjet outcomes all available from a single RAW file.

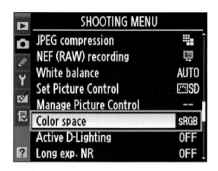

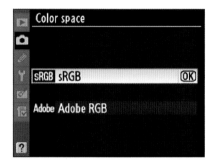

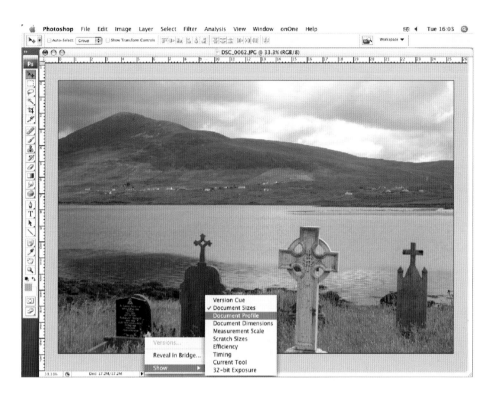

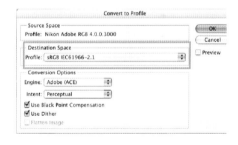

Option 2: shoot sRGB files

The simplest, if not the ideal, way of managing colour for a book project is to set your camera to use the sRGB colour space before shooting, as shown above on the Nikon D3.

Found within the shooting menu on most digital SLR's will be at least two options under the Color Space menu: Adobe (1998) and sRGB. Select the sRGB option and come out of the menu.

When your images are created and stored on the camera's internal drive, they will be tagged with the sRGB space. The colour space tag will be attached to all files types including JPEG or TIFF, and any dual file-format saving routines.

The downside of this method is that you are effectively setting a limited response to colour from the outset, as there's no way of re-assigning a bigger colour space later on.

Option 3: convert in Photoshop

If you are unsure about the colour space tag your project files have been created in, first check them in Photoshop. On the base of the image window, click-hold the tiny right-facing arrowhead until two pop-up menus appear, as shown above.

Select the Document Profile option and watch how Photoshop displays the tag information at the base of the image window for you to see.

At this stage, there are three likely scenarios. Firstly the image has been created in sRGB, so no further work is required. Secondly, your image has been created without a profile altogether (a possibility if it has been scanned or generated from an older device). Thirdly, it has been created with a different profile, which now needs converting.

Using Convert to Profile

From the Edit menu, choose Convert to Profile and set the options as above. Start in the Destination Space pop-up menu and choose the sRGB colour space from the long list that appears. Next, choose the Adobe ACE colour-managment engine together with Perceptual as the Intent to make the most visually acceptable results.

Finally select Black Point Compensation and Dither.

Soft-proofing your images

The professional way to prepare your images is to edit under Photoshop's soft-proof viewing conditions. What you see on the screen, will look very close to your printed book.

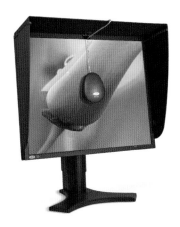

BlurbB3_CMYK.icc

HP5000SemimatteExp 05.icc

Calibrate your monitor

The first step in colour managing your workflow is to calibrate your monitor, using a hardware profiling device like the Blue-Eye, shown above. This is a much better alternative to using a step-by-step calibration application like Adobe Gamma, as it removes all traces of human error.

The hardware profiler attaches to the monitor and runs through an automated series of measurements, which are then collated, processed and built into a bespoke ICC profile for your own monitor hardware and environmental conditions.

The profile is then utilised by your computer's system software, resetting any unwanted alterations to the profile and ensuring your display is neutral and set at a standard brightness and contrast. Priced at around £100, it's money well spent.

Digital press ICC profiles

Despite the fact that all inkjet paper manufactures provide free ICC profiles to support photographers' quest for colour accuracy, the same cannot be said about digital press manufacturers or book printers.

With so many ink and paper variables in the commercial printing industry, this is hardly suprising, but there are some generic ICC profiles for the latest HP Indigo press models in existence, if you search the photo-blogs for long enough.

Currently, Blurb's professional B3 service is the only one to provide a custom-made ICC profile which is matched to their Indigo press, inks and specific paper type. The profile is free once you add this optional service to your otherwise free membership and offers the best way of predicting how your images will reproduce on the page of your book.

What are ICC profiles?

To control the translation of colour numbers from one colour space to another, professional photographers use profiles in their workflow. The universal standard for colour was set by the International Colour Consortium and all subsequent profiles are designed to be used across different hardware devices, computer platforms and applications.

The actual profile file itself is best visualised like a cipher: a set of instructions for translating a string of colour-generating code created in one language into another.

When you are working with two spaces as visually different as sRGB and CMYK, the profile will enable you to see how the translation will look before it's made. Equipped with this knowledge, you can then make compensatory edits to your file to lessen the visual impact of the change.

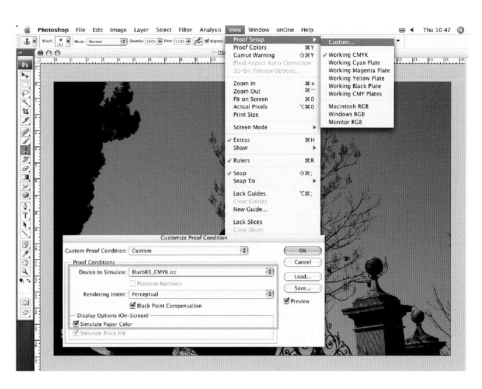

Installing the profile

Once downloaded from your service provider, the profile will appear on your desktop with a tiny rainbow gamut icon with the .icc file extension, as shown above.

Before it can be used, you first need to place the profile file in the right folder for Photoshop and all other colour-managed applications that may need to reference it.

On an Apple computer, the profile needs to be installed as follows:
Main HD⋯▸Library⋯▸ColorSync⋯▸Profiles.

On a Windows PC, you can either right click on the actual profile icon, then select Install Profile, to place it automatically, or place it into this directory:
C Drive⋯▸ProgramFiles⋯▸Common⋯▸ Adobe⋯▸ Color⋯▸ Profiles⋯▸Recommended.

Be sure to keep checking with your provider for new profiles, as they can be updated frequently.

Soft-proofing in Photoshop

After loading the profile into your system, open your image in Photoshop, then do a View⋯▸Proof Setup⋯▸Custom command, as shown above. In the dialog box, choose your desired profile from the Device to Simulate pop-up menu, in the above example the Blurb B3 CMYK profile. Next, select the Perceptual rendering intent, plus Black Point compensation and Simulate Paper white options. These three selections will present the closest possible recreation of the printed outcome on your screen.

Before clicking out of the dialog, tick the tiny Preview option on and off, so you can see the difference between the soft-proofed and the straight screen image. The current profile which you are proofing with, will now be displayed across the image's top window bar.

Using a generic CMYK profile

If you decide to use a non-colour managed book prodution service, i.e., one that does not provide a press profile for download, you can prepare your image files with a generic profile instead.

Most recent versions of Photoshop are equipped with several CMYK profiles, so to set up your soft-proof conditions, simply choose the US Web Coated (SWOP) V2 profile, as shown above.

The only downside to using this profile is that it's designed to show how your image will appear on coated paper, which may not match the kind of printing paper used by your chosen book printer. Most use a glossy coated paper, but some use a semi-matte paper stock. Despite this, the generic profile is a much better option than not soft-proofing your images at all.

Non-destructive editing

The latest buzz-word in image processing is used to describe the many techniques for enhancing an image whilst maintaining original pixel data.

Although the term, 'non-destructive', has only recently appeared as part of our technical lexicon, image-editing programmes have able to work in this way for the last fifteen years. In simple terms, non-destructive processing describes the methods by which original image data is protected throughout an editing sequence and not over-written with each command.

When a digital image is first opened, the image editor converts the complex strings of pixel data into colours, shapes and lines. If this original file is never modified and re-saved, this original data is left intact.

In the same way as traditional film images degrade after duplicating and copying, so a digital file deteriorates when the cumulative effect of editing starts to show. To avoid this, original digital files can be preserved as a kind of latent digital image, to which you can always return and re-process the raw data created at the sensor.

Examples of non-destructive tools are Photoshop Layers, especially Adjustment Layers and, in recent releases, the innovative Smart Objects and Smart Layers. All of these functions, when combined with saving in the Photoshop PSD format, preserve original pixel data, while you ponder and reflect on the suitability of your editing. At the opposite end of the scale, every single edit applied through a dialog box or menu, accompanied with a save command, will permanently over-write and distort your original data.

Best-case scenario

To ensure maximum creative flexibility and to future-proof your work, it's essential to shoot in the RAW file format. Nowadays most digital SLR's provide RAW file capture facilities, so you can shoot and store a universal digital file.

RAW files can never be overwritten in your imaging application and thus provide the best way of archiving your work for future re-use. For many photographers who are shooting with perhaps three very different media in mind, such as web, desktop print and on-demand book, this universal format makes perfect sense.

RAW files can only be edited in the Camera Raw plug-in or Adobe Lightroom and will need to be exported after processing in a specific format to be layout-ready. Most on-demand publishing services provide template-based software for producing a final book design, with many only accepting the ubiquitous JPEG file format for importing images into a spread.

If you are forced into exporting your RAW files into this format, always opt for the highest quality compression settings. This will not offer a foolproof way of maintaining maximum quality, as the template may also apply a secondary compression to the embedded image, but it's a start.

Global versus local editing

The choice of image-editing tools to use for your book project really depends on the nature of your own work. Many photographers who have switched from Photoshop to Lightroom or Aperture applications, have done so because the latter offer a refreshing alternative that streamlines previously complex working processes.

If your photographic images do not involve montage or the application of filter effects, then there's really no need to use a complex tool like Photoshop. Instead, opt for Lightroom and enjoy the simplicity of its interface and the luxury of preparing your file for output in the minimum number of steps possible.

In general, images that have been exposed perfectly in-camera are much less likely to display noise or any other image artefacts after processing, so they need only small adjustments to reach their full potential.

Although Lightroom only offers global editing tools (no selection masks are available), plus a cropping function, this may well provide you with enough processing power to create bright, sharp and tonally corrected images ready for inclusion in your book layout. At the back-end of the application is a versatile export function which can deliver your completed files to your book project folder or online photo-storage site.

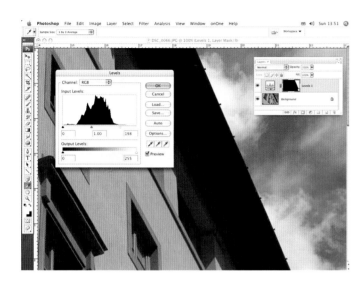

Adobe Photoshop is the best tool to use for making localised edits to specific parts of the image. Non-destructive editing takes place through the use of Adjustment and Smart layers.

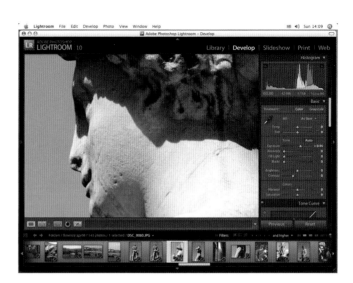

Adobe Photoshop Lightroom maintains its non-destructive workflow by recording the sequence of commands applied to an image. These remain separated from the original file until an Export command is instigated.

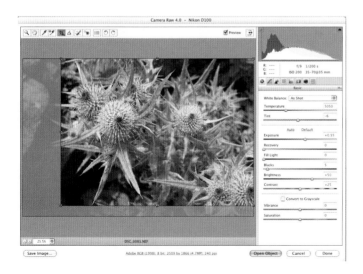

The Camera Raw plug-in extends the functionality of Photoshop by providing a non-destructive toolbox. As with Lightroom, the original file remains unaffected until exported.

Camera Raw records the commands applied to an image in a separate XMP file, as shown above. Once the image is re-opened, the previous sequence of commands is replayed, but remains reversible at all times.

Online editing and preparation

A step-up from online photosharing sites like Flickr, Photoshop Express offers you file storage together with useful online image-editing tools too.

The brand new offspring of the Photoshop family of applications is Photoshop Express, designed to facilitate online storage and editing of digital images. Unlike other social networking and photosharing services, Photoshop Express provides a set of useful editing tools for you to enhance your files.

The service is available through any internet-connected computer, both PC and Mac platforms, and works within a standard web-browser interface. At the time of writing the service is free and offers an enormous 2Gb of storage space. This is enough to accomodate around 600 high quality JPEG files, the only file format accepted by the service at the time of writing.

The advantages of using such a facility are extensive: you can store, edit and share your work whilst away from home and away from your imaging workstation, too. For location or travel photographers spending long periods abroad, this is an ideal way to manage files and even enter into some rudimentary, first-stage editing.

The service works simply by dividing your password-protected area up into galleries, within which you can share with others; albums, which you can organise images into and a simple editing interface, where you can alter your image to create the intended outcome.

The toolbox

Unlike other network-based applications, Photoshop Express very usefully permits versioning as you work through an editing sequence. There's no danger of over-writing the original online file, even if you instigate a Save command after the edit, or quit your session without reverting. This excellent feature means that, as with using Lightroom, you can return to your image and remove your previous edit with a simple click.

Within the limitations of your network connection speed and your computer's processing power, the image-editing tools provide real-time previews without the need to click or slide a control bar. Most of the image-enhancing tools work by displaying a range of options (much like Photoshop's Variations dialog) across the top of the working window. When the cursor floats over the variation, the full-sized image changes immediately below, so you can see the instant effect of a range of different changes quicker than you'd imagine from a network-based source.

Although the subtlety and fine tuning available in both Lightroom and Photoshop are not yet present in Express, there's enough tricks in the box to rescue and resuscitate a flat image and prepare it for layout in a book. When complete, you can download the file for print or, in the future, deliver it to an online service.

Links and bridges

Many new applications are now providing useful workflow links to each other and to a range of online service providers, and Photoshop Express follows the trend. At the time of writing, Express provides an internal link to FaceBook, Picasa and PhotoBucket, so you can simply retrieve personal images that you have stored on other sites. Known as slurping, this useful function presents a one-way path into Photoshop Express, so you can modify your image files to match your desired output.

Many on-demand book publishing services such as Blurb also provide links and bridges to other photosharing sites and storage providers, so you can move your content around a very convenient virtual desktop.

If you are planning a complex publishing project where you will be moving between locations, and versions and possibly working to an ever-changing brief, then a purely online workflow can make real sense. The only downside to the process is that you are committed to working with JPEGs and have no actual hands-on colour-management tools at your disposal.

Weblink
www.photoshop.com/express

Adobe Photoshop Express provides a simple album interface, so you can view your images at different sizes before editing takes place.

Photoshop Express can also be configured to exclude your browser's screen furniture, so it occupies the entire desktop like a standard application.

A full sized preview image, showing the tools available on the left-hand side of the screen. This image is in an unedited state.

When any of the tools are active, a new horizontal panel displaying a range of variations appears at the top of the screen. Small tick icons appear next to the tools you have used, so you don't repeat their use by mistake.

Contrast adjustment

Preparing the contrast of your original image file in line with the limitations of the digital printing press will ensure your printed book looks its best.

Step 1: View as Soft-Proof

There's really no point in adjusting the contrast of your image unless you soft-proof it to your destination output device first.

To maintain maximum flexibility and to avoid degrading your image, the soft-proof effectively presents you with the worse-case scenario straight away. Your task from that point onwards is to edit the file into visually better shape and, while the soft-proof remains visible, you will always stay within the gamut of your chosen press/ink/paper combination.

The example above shows how different a midtone red reproduces when soft-proofed under a HP Indigo 5000 profile. The left half of the montage is seen without the soft-proof option, while the right half is viewed with the soft-proof switched on. Notice how the red is much more muted in the soft-proofed version.

Step 2: Make Adjustment Layer

Start your editing by correcting the brightness and contrast of your image using Curves. In your Layers menu do a Layers···▷New Adjustment Layer···▷Curves command and watch how the Adjustment Layer pops up in your Layers palette, as shown above.

Unlike a normal pixel-based layer, an Adjustment Layer contains only settings, which effectively 'float' over your background layer. By keeping the setting separate from the background layer, you are preserving all original pixel values created at the point of exposure.

In fact, the Adjustment Layer provides you with the ability to interpret your original file rather than embedding each and every command. You can keep returning to the Adjustment Layer to modify your choices, simply by clicking the Curve dialog icon in your Layers palette.

Step 3: Add mask if required

The most sophisticated way of controlling contrast and brightness with Adjustment Layers is to apply them through a mask. The mask is no more complex than a paper stencil, and works by allowing an edge-to-edge global edit to 'shine' through the hole on the layer underneath.

To start, ensure that white and black are reset as the default foreground and background colours in the toolbox. Next, select the Eraser tool and load it with a large soft-edged brush and then apply to the image. Loaded with white the Eraser cuts holes into the mask; when loaded with black, it repairs holes in the mask. You can therefore keep refining your mask until it covers exactly the right parts of your image.

Looking at the mask icon, black shapes denote the opaque part of the stencil, while white areas denote the 'holes'.

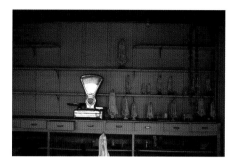

Scenario 1: Flat JPEG original

Straight out of the camera, a typical JPEG will look slightly dull with flat contrast and muted colours. If this is used immediately in a book layout programme, the resulting prints will look the same or even darker.

Scenario 2: High-key areas

Some images are exposed with lots of high-key highlight areas, like the example above. Apart from confusing the camera meter, excessively white areas must be edited out, or they'll get worse in repro.

Scenario 3: Low-key subject

A more delicate operation. The task is to open up, or lighten, the shadows so they don't increase during repro, but without ruining the atmosphere of the original image.

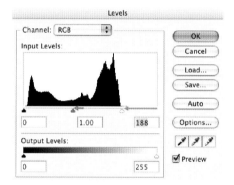

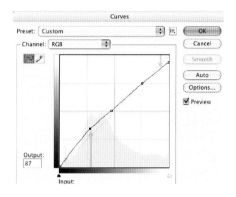

Scenario 1: Rescue with Levels

Move the white point, as above. If still dark, slide the midpoint triangle to the left.

Scenario 2: Rescue with Curves

Change the highlight into pale grey (top right) and lighten the shadows (bottom left)

Scenario 3: Lighten with Curves

Lighten the shadows by pushing the curve upwards (bottom left).

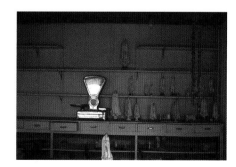

Scenario 1: Corrected

Scenario 2: Corrected

Scenario 3: Corrected

Colour adjustment

With the all-important soft-proof view switched on, you can safely adjust the colours in your image to get the very best out of the digital printing press.

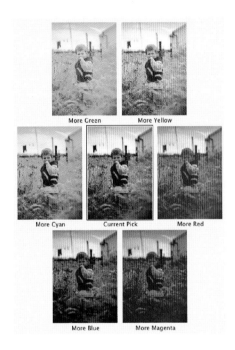

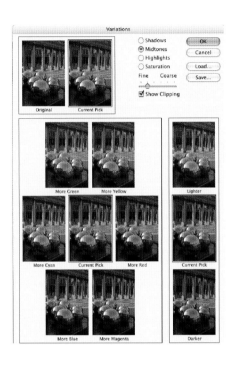

Colour balance essentials

There's no mystery to getting accurate colours from your images, you simply have to know the underpinning theory before you start adjusting. Colour is controlled by three pairs of opposites: green and magenta, blue and yellow, cyan and red. When a colour cast is identified in your image, it can be removed by adding more of its opposite colour. For example, if your image was too blue, it can be made to look neutral by adding more yellow. In Photoshop, these opposites are arranged in both Variations and Color Balance dialogs.

Step 1: Using Color Balance

After adjusting the brightness and contrast of your image using a Levels or Curves Adjustment Layer, the next step is to correct any colour imbalance using a Color Balance adjustment layer.

The dialog box allows you to pull and push colour values in tiny proportions, so you can remove any lingering colours. Most casts are usually caused by environmental issues, such as the colour temperature of natural light (cold and blue in the morning and warm and red in the evening), or by an unexpected artificial light source. You can also use Color Balance to creatively improve colour, perhaps to warm up a cold scene.

Alternative Step 1: Variations

If you are unsure about identifying and correcting colour casts, then the Variations dialog is the best option. Although it can't be applied through an adjustment layer, it can be applied non-destructively as a Smart Filter to a Smart Object.

In use, the Variations dialog presents the three colour pairs arranged around your image in its current state. Reversing out of a bad edit is possible at every stage by clicking on any of the Current Pick states. Vary the rate of change by moving the Fine/ Coarse slider.

Scenario 1: Tungsten cast

Although Auto White Balance is the best setting to use on your DSLR, sometimes an artificial light source will cause a cast. This above example has a typical heavy yellow/orange cast.

Scenario 2: Fluorescent cast

A fluorescent light source will drown your image in a heavy green cast. This image taken of a shop window shows a heavier cast in the shadow areas compared to the midtones and highlights.

Scenario 3: Shaded subject

Shooting against the light is never a good idea, but it is possible to colour-adjust mistakes to make them usable. This example above has a blue/cyan cast on the white signage.

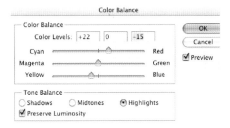

Scenario 1: Fix with Color Balance

Casts created by a light source must be removed by the Color Balance dialog in both Highlight and Midtone areas. Start reducing the yellow in the Highlights, then click into Midtones to repeat a lesser edit.

Scenario 2: Fix with Color Balance

This time, start at the Shadow end of the Color Balance dialog, reducing the amount of cyan. Don't be afraid to add colour to warm up the image, using a touch of yellow.

Scenario 3: Fix with Color Balance

Remove the blue cast by clicking the Highlight radio button, then adding yellow. Add a little red too, just in case there is any cyan lingering.

Scenario 1: Corrected

Notice the new tones and shapes appear.

Scenario 2: Corrected

Notice the less distracting background.

Scenario 3: Corrected

A much brighter end result.

Special black and white

There are several different methods of reproducing monochrome images on a digital press, from basic greyscale mode to advanced colour-separation techniques.

Greyscale mode

The most basic method of preparing an image for book production is through the Image⋯Mode⋯Greyscale command. The resulting image is stripped of its colour data and becomes composed of only 256 tones in a single black channel file.

When output on the digital press, only the black ink is used, producing a visually weaker kind of reproduction with no warmth to the image at all.

A greyscale mode file can be saved in either Tiff or JPEG file formats, so is suitable for importing into both book template and DTP software.

Tinted mono in RGB colour mode

A better way to prepare monochrome images is to keep them in the RGB image mode throughout the editing process. In RGB mode, all tints, hue changes and digital toning are retained, producing a richer end result.

Before printing, the RGB image files are separated automtically into four channels: Cyan, Magenta, Yellow and Black. This separation process is usually managed by the driver application for the digital press. As an end-user, you have no control over this final process. Like greyscales, RGBs can be saved as either JPEG or TIFF files.

CMYK process colour duotones

The most adventurous way of preparing a mono image for the press is to use Photoshop's Dutotone mode. Unlike the RGB image mode, a single channel image is created with the addition of one additonal ink colour together with black. Duotone image mode is a great way to enhance the dynamic range of a monochrome image.

Start by picking any Process colour palette in the Duotone Color Library, as shown above top. To control each of the four CMYK process colours, Photoshop presents a simple curve dialog.

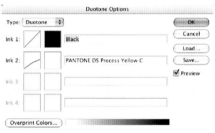

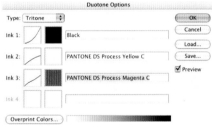

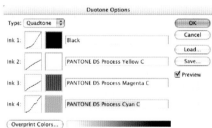

Black/yellow duotone

The simplest of all duotone techniques is to use Yellow with Black. First convert your image into the Greyscale mode, then return to the Image➞Image Mode dialog and choose Duotone. Click into the empty white colour box, sitting below the Black to choose Process Yellow.

 Next click on the tiny curve icon, where you can push up or pull down the diagonal line to make the colour lighter or darker in ten distinct tonal sectors. This example above placed yellows into the midtones, but removed them from the shadows.

Black/yellow/magenta tritone

For this example, process magenta was added as the third ink colour to the mix. Before acting on the magenta curve, the Black curve was manipulated to remove black from the highlights and midtones, denoted above by a gentle downward bow shape.

 Next, magenta was introduced to the midtones by creating a gentle sloping 's' curve, stopping well before the 80% limit. The resulting colour mix is warm and makes an interesting reproduction out of a bland monochrome starting point.

CMYK quadtone

Maximum dynamic range is created with the use of the fourth process colour cyan, in a quadtone image. Notice how the shape of the cyan curve above creates a split-toned effect on the final image.

Using Duotones

Dutones must be saved as EPS files to retain their settings, but only DTP applications will accept EPS format imports.

Resizing and resolution

It's much better to make your image the right size in Photoshop before importing, as resizing on the layout might cause a reduction in quality.

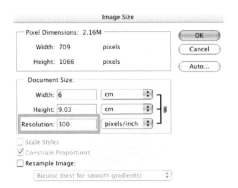

Step 1: Set the resolution

Images for digital press reproduction need to be prepared and saved at 300 pixels per inch, rather than the 240 ppi setting used for inkjet printing. There's no need to prepare images any higher than 300, as you will see no noticeable benefits, but if images are prepared at less than 300 ppi, they will appear blurred or, at worst, pixellated on the printed page.

The best way to prepare your images for layout in either template or DTP applications is through the Image Size dialog box, as shown above. Ensure that the Resample Image box, bottom left, is left unchecked, then change the Resolution dialog box to 300 as shown. In the Document Size panel in the middle of the dialog, you will now see the maximum size that the image can be reproduced in your book layout, ensuring top quality.

Step 2: Scaling up

Once your resolution is set, the next step is to prepare your images at the right size for importing into your page template or DTP application. When preparing images for inkjet output, your final print size is determined early on in the process, but laying out a book is much more fluid. Image size is not certain until your design is completed, so it's essential to resize your images only at the very end of the process.

Most images start to lose sharpness if they are enlarged to more than 20% of their original size, so although it's possible to make a giant image, the result won't be pin sharp. Open the Image Size dialog and select the Resample Image box and the Bicubic Smoother method from the pop-up menu, as shown above. Now type the new size in the Document Size boxes and press OK.

Step 3: Scaling down

Although both template and DTP applications provide tools for resizing images after importation into your book, you'll get much better results if you do this in Photoshop. To make your original image smaller than its capture size, take a note of its desired size in your layout application, then open the image file in Photoshop.

Now select the Resample Image check box together with the Bicubic Sharper method, as shown above. This technique of removing pixels from a bigger original ensures that the scaled-down result does not appear unsharp after large-scale changes.

With both resizing techniques, it's essential that you rename the new image file before saving it back into your project folder, or it will over-write your high-resolution original.

When digital images are prepared at the correct resolution, they appear sharp on the printed page.

When prepared at too low a resolution, or enlarged by more than 10%, images will appear blurred.

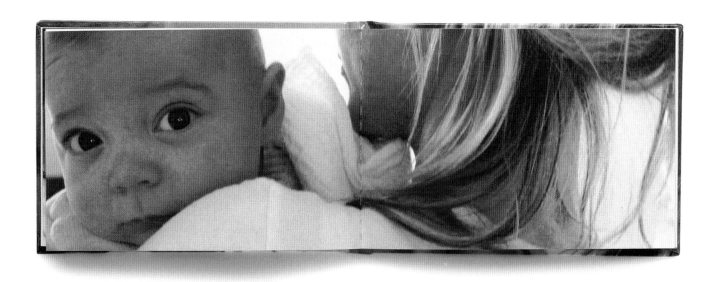

This example of a full-bleed layout from BoBooks, uses an unconventional but very effective crop to place a single image across a spread.

Chapter 4
Book design tools

···⟩ Managing your files

···⟩ Using Booksmart

···⟩ Using iPhoto

···⟩ Cheating template software

···⟩ Using DTP software

···⟩ Portable Document Format

···⟩ Using PhotoBook Proofer

Managing your files

Before embarking on a publishing project, it's important to collect all your creative assets and store them in them in the most convenient place, online or on a drive.

Adobe Bridge

Before Bridge was introduced, it was tricky to access large volumes of images through Adobe Photoshop's standard File⟶Open command. With tiny previews of a single image at a time, locating the right file became very frustrating. Nowadays, most Photoshop creatives use the File⟶Browse command to launch a more organised way of retrieving the right files.

Bridge is no more than an advanced file-browsing application which works independently from the suite of Adobe applications, so you can view a large volume of images simultaneously. Like many other viewer/browser applications, Bridge displays a variety of nuts-and-bolts information about your file, such as the camera settings used at the point of capture.

Bridge comes into its own, however, when you use it to catalogue shoots and to make early edits, before begining to layout your book. Much as you would view conventional contact or index prints, you can use Bridge to reflect on your shoot and to start planning your book's sequencing.

Once an image has been selected in Bridge, a simple double click will open it in Photoshop, so you instantly get to work on your chosen document. Bridge can also be used to synchronise colour- management settings between different applications such as InDesign, Photoshop and Acrobat.

Slurping

With the growing use of social networking sites and online storage facilities, Blurb has had the foresight to provide an easy way to round-up content that exists in the virtual world, rather than on your computer's hard drive.

Slurping is the name given to the automated process whereby BookSmart imports existing text or image files into a book publishing project directly from another website. The process takes much less of your preparation time, but assumes that the quality of the content is suitable for printing.

BookSmart provides a simple link to Flickr, so you can directly import your own work into a book, without needing to transport your files and re-edit them. There's also a link to a popular blog site, Blogger, so you can transform an online text commentary into a book just as easily as you would key in an original text.

This portability of content is excellent news for those planning to spend a long time away from home, as you can contribute text and upload images to your preferred online source at regular intervals during your time away, then turn them back into a physical book on your return. Some of the most interesting travel books and journals have been created by re-using blog content.

Collaborative projects

BookSmart also provides additional functions for gathering material from lots of different sources, as might be required for a group or collaborative publishing project. Persmissions are established by a single project administrator, who determines who gets access.

This potential for linking many different contributors to a single project is an excellent way of producing community-based work, reviews or any publication where collaboration is at central to the concept.

Lightroom plug-in modules

In addition to facilities for pulling in image files and text over a network, there are also optional plug-ins for adapting content generated in and exported from Adobe Lightroom. These specialised plug-ins offer a convenient way to short-circuit the time-consuming logistics of exporting each processed file individually, since you can deliver an entire set of images to your project folder with a single command.

Weblink

Get the free Lightroom export to Flickr plug-in here:

labs.adobe.com/technologies/lightroomsdk

Adobe Bridge provides detailed file information together with thumbnails at scalable sizes, so you can better preview images for your project.

Captured images are best stored in a single project folder on your drive, which can be easily referenced by Bridge. In the left-hand panel you can create shortcuts to commonly accessed folders.

Bridge can also be configured to show a sizeable preview of your chosen image within a large pane, shown above top right. This enables you to do a quick check on sharpness and exposure.

Unlike Photoshop's File>Open command, Bridge provides large preview thumbnails, so you can reflect on your editing decisions.

Using BookSmart

Booksmart is a free application for designing your own photobooks, using simple templates and a straightforward drag-and-drop method of assembly. No desktop-publishing skills are required.

How Booksmart works

Like many other on-demand printing services, Blurb offers their software, Booksmart, free to registered users. The application is available for both Mac and Windows PC users and is easily downloaded from the Blurb website. Booksmart is primarily aimed at non-designers and is equipped with plenty of layout tools to help position both images and text.

Once launched, Booksmart prompts you to choose the style and shape of your book, but like all other decisions made in the application, this is reversible at all times. Booksmart cleverly enables you to define your source images not only from a local disk or drive, but also from your own online source like Flickr. When your source images are identified, they become visible in Booksmart and can be simply dragged and dropped into position on to your page layout.

The book project is essentially divided into two components: the cover and the insides, and Booksmart allows you to add, move and delete individual pages as you work. Each of the two components has a set of pre-designed templates, which you can use to provide the layout grid for your book. With so many options to choose from, it pays to experiment with a few before committing to an overall style for your project.

The cover component

The most important part of any book is the cover design. Booksmart offers two kinds of book to design and purchase: the hardback with dust jacket and fold-around flaps and the simple paperback. This example, above, shows a hardback book-cover template in use, with images positioned on both rear cover (left half) and front cover (right half). Additional space is also made available on the fold-over flaps for more images and text, as this will be printed on a single sheet of paper on the digital press. Booksmart also allows you to use your computer's entire range of fonts, rather than a restricted few, so you can deploy your creative talents to the full.

Ordering, proofing and exporting

At the end of the design process, Booksmart creates a repro-ready file for online submission to Blurb, so you can order your book and place it on public sale. The ordering process is contained within Booksmart, so there's no need to open a separate web browser. Before this stage, you can also save the cover and the insides (but not both together) as PDFs, so you can make simple proof prints to check before ordering. Booksmart also allows you to save your project file, through a File⋯⟩Export command, creating a .book format file which can only be re-opened in Booksmart, but offering you the flexibility to take your project to another workstation.

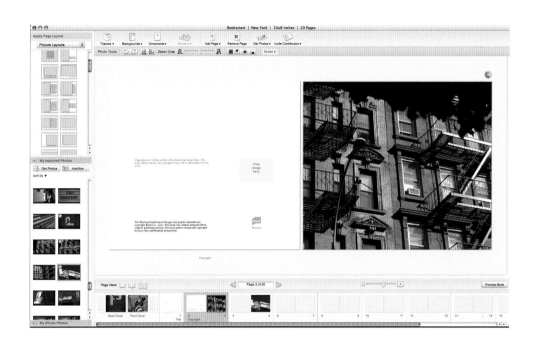

Assembling the insides ⋯⋗

Booksmart enables you to quickly drag-and-drop your source images into the page and create crops and rotations to improve the page composition. This example, right, shows a rectangular image which has been pasted into a square template. Booksmart allows you to position the image within this template, so you determine the exact point of cropping. Notice also the tiny horizontal thumbnails at the base of the window, describing the layout sequence in spreads.

Desktop preview ⋯⋗

With a mass of tools, panels and window furniture surrounding your book design, it can be difficult to visualise the end result. Booksmart usefully provides a Preview mode, removing all editing tools from the desktop to help you comtemplate your work in progress. In this example, right, the full-bleed image of a street sign looks much more effective when the template guides are removed.

Using iPhoto

The latest version of Apple's popular image utility provides simple editing tools and a step-by-step method of making photobooks from your digital images.

iPhoto overview

iPhoto is an Apple-only software product that is designed to simplify image archiving, processing and retrieval. It can be used as an alternative browser to Adobe Bridge, providing a direct facility for digital camera uploads. Like iTunes, iPhoto offers a simple method of organising your files into different projects and collections without the need to make multiple copies.

The latest iPhoto application also provides a range of image-editing tools, so you can fix and enhance your images before using them in a layout.

The floating Adjust panel is especially useful, providing a Levels-like histogram and a range of simple sliders for correcting exposure, highlights and shadow areas. There's also the facility to sharpen your images and minimise noise.

iPhoto books

iPhoto provides a seamless link to Apple's own online book-production service, where you can choose from a variety of styles, layouts and extents. The only slight downside to this process is that the range of products and printing services is different for different versions of iPhoto.

iPhoto is now bundled with Apple's creative utility suite called iLife. Thus, although this is a low-cost product, it is not available to buy as an individual application.

You can pick from a range of templates before, during and and even at the end of an iPhoto project, as shown above, so you have maximum flexibility.

Although Apple was one of the first to offer a book-making service direct from a photo application, early iPhoto books could not compete on quality with those from Lulu or Blurb.

iPhoto provides a simple and effective browser interface, where you can preview your project files before assembling them into a photobook

The floating Adjust dialog box, shown top right, provides essential image correction tools. The Effects dialog box, shown bottom left, previews the image under a number of different creative colourings.

iPhoto provides a range of contemporary layout templates, so you can assemble stylish visual projects.

A finished book project, ready to proof read and check before ordering.

Cheating template software

There is no reason to restrict yourself to the use of template software, you can easily supplement it by using other applications to generate artwork.

Reason 1: To use type effects

Most template-based book-design software gives you access to your own individual font pack, as installed on your own workstation. This won't allow you to apply type effects to your images, but there are ways round the problem.

A great way of making your book covers stand out from the crowd is to apply a type effect in Photoshop, as shown above, and save the finished file as a high quality JPEG for importing into your book project folder.

Book covers all start to look the same when you visit the bookstore pages of an on-demand provider like Blurb, so it's well worth spending time preparing your cover to look different.

The above example was created using Photoshop's Type Mask tool to copy and paste pixels into the type outline shape. Always use a thick, heavy-bodied font, preferably sans-serif.

Reason 2: To make a montage

Multi-image layouts can look really effective, but most template applications provide only family-oriented examples which are not suitable for all subjects.

A good reason for stepping outside the template software is to make use of Photoshop's layers and transparency techniques to make a unique montage image, which can then be imported into the template.

The example shown above combines three different aspects of the same location, arranged in a way that would be impossible using template place-holders, Making composites like this also allows you to crop and transform images into the right shapes and to remove any unwanted areas.

Always work at 300 ppi resolution when making montage pieces and scale down to the required repro size at the very end of your editing.

Reason 2: To use creative edges

Creative edges can add a personalised touch to your layouts, mimicking the look of a traditional album or journal.

This example above was created using the excellent OnOne PhotoFrame Pro 3 application, a Photoshop and Photoshop Elements-compatible plug-in. The plug-in works by providing a huge range of creative edge effects in a library, so you can present your image with style. The edges can be used to further crop an image into a particular shape, such as a square, or to assemble a multi-image layout for importation into your book assembly application.

Look out for the additional frame-like edges that provide a simple way to make a personalised album-style layout. Always apply your PhotoFrames to a new layer in Photoshop to allow maximum flexibility when blending and masking the results.

Laying out using InDesign

InDesign provides all the tools you need to arrange images and text precisely on the page. Unlike template-based book applications, it allows you to create your own layout grids and place-holders for text and images at any size or shape to fit your project.

The principles are simple, create a new document based on the exact dimensions of your chosen book size, as determined by the template software. Next, fill the InDocument with your specially arranged layouts, fonts and special graphic effects that are otherwise impossible to create.

Finally, finish and export the individual pages straight into your book project folder, to ensure all special fonts and vector artwork can be recreated.

Exporting as JPEG's

InDesign version CS3 provides a useful new function for photobook makers: the ability to export your designed pages at 300 ppi resolution.

After your design document is complete, choose the File⸱⸱⸱› Export⸱⸱⸱›JPEG command as shown above. In the Export panel, choose either specific pages to export or the entire document. Next, in the Image panel, set Maximum quality, Baseline as the Format Method and finally set the resolution to 300 ppi.

The new JPEG's can then be loaded into your photobook template application and inserted into the place-holders like any other image.

Colour control in Creative Suite

If you have InDesign, Photoshop and Bridge as part of the Creative Suite package, they can all be linked together to provide colour consistency, so you can swap images across applications without fear of the problems associated with converting between colour workspaces.

The best way of doing this is to establish your core colour settings in Bridge, through the Edit⸱⸱⸱›Creative Suite Colour Settings controls.

InDesign colour management

InDesign alone provides comprehensive colour-management tools so you can preserve the colour characteristics of your image files when they are imported.

Always configure the colour settings before using the application and ensure that you make the necessary changes if you have shot a book project in the sRGB colour space.

InDesign also provides an accurate soft-proofing preview, so you can see the likely outcome of your print outs before they are made. If your images start to lack that vital contrast and colour vibrancy in the layout, go back to your master file and enhance the file until it looks better.

The same press profile used in Photoshop can be used in InDesign to simulate the likely appearance of the finished book.

Using DTP software

Better on-demand book printers allow you to submit press-ready layouts created in QuarkXpress or InDesign, so you can make full use of your full design skills.

Professional applications

Unlike template-based applications such as BookSmart, a professional desktop-publishing application like InDesign will allow you the creative freedom to define your own layout style and typographic refinements.

Compared to image-processing applications, DTP programmes are relatively straightforward tools to use, using vector design tools such as text, lines and boxes, coupled with the ability to import raster or pixel images. InDesign also shares many features with Photoshop, such as shortcuts, colour-management settings and soft-proofing.

Getting started: golden rules

When an image is imported into a DTP layout, the application inserts into the page a low-resolution preview that is linked to the source file. It's therefore important to manage your image assets properly. Make a project folder in which to locate all your image assets and never be tempted to rename any files.

Although you can perform simple image editing in DTP applications, always resize images before importing and never rotate an image in a layout. Package images in the TIFF format, not JPEG, and use the Unsharp Mask filter sparingly, or dispense with it altogether. Finally, unless you posess the output profile, leave images in the RGB colour mode, don't use a generic CMYK.

Setting up a document

If you are making a photobook with a printed cover, you will need to create two separate documents: one for the inside pages and one for the cover. You will need to ensure that you get the document dimensions before starting, especially if you are designing a wrap-around dust jacket.

Always set up master pages before starting your layouts, these work like a template for each spread that you add to your project. Always use style sheets to define your use of type, i.e. specific recipes of font, size and spacing so you can achieve consistency in your document. You can keep track of your work in progress by previewing pages and spreads, as shown above. This also provides you with the chance to get the running order correct.

Collect for output and exporting

At the end of the project, InDesign provides a comprehensive set of tools to ensure your document is ready for output. With so many different assets involved in a project, including images, graphic files and fonts, the pre-flight check is well worth doing.

The check effectively anticipates problems with missing images, low image resolution and wrong colour space, so you can correct costly mistakes before it is too late. Finally, the Package command copies all the project assets into a new folder, ready for you to deliver to your service provider.

As part of the Adobe Creative Suite, InDesign can seamlessly export project files into press-ready PDF files, without the need to process in another application.

Precise tools

InDesign provides all the tools you need to arrange images and text precisely on the page. InDesign, unlike template-based book applications, enables you to create your own layout grids and place-holders for text and images at any size or shape to fit your project.

Preview functions

The many different preview functions in InDesign also help you anticipate problems before they arise. The Bleed preview, shown left, predicts the position of the guillotine cut, an essential check if you have bled any images or graphics off the edge of the page.

Portable Document Format (PDF)

Adobe's revolutionary format works by locking together the essential components of a document so it can be delivered and printed without anxiety.

How Acrobat works

The delivery of most documents from design studio to the printing press is facilated by the use of an intermediate PDF file. When a design document is being created, using a range of specialist graphics packages, a variety of different elements such as images, vector graphics and fonts are involved. A PDF 'fixes' all these elements in a single document.

At the consumer level, the PDf file is used to embed non-standard system fonts, artwork and images into a vector document that can then be viewed or printed by anyone. It's lean on data and is a standalone file, needing to import no special fonts or images, and can be quickly emailed as an attachment.

Unlike Word documents, which can easily change formatting depending on the receiver's computer set-up, all the elements in a PDF are locked into place and will print as intended. Many national newspapers now offer PDF versions of their products and most technical software manuals are now supplied as PDFs if you want to print, or to view, them.

In the professional publishing industry, further variants of the PDF are used to deliver the same certainty, but as high-resolution, press-ready documents. Bridging the gap between design studio and commercial printer, the press-ready PDF offers advanced workflow options, including colour management and image compression.

Using PDFs for a photobook

If you plan to construct your photobook through a DTP application, it's likely that you'll be asked by your printer to package the final file as a PDF. The preferred delivery format for printers and designers, PDF provides a 'locked' document that can't be altered by either party, thereby avoiding any disputes over liability if problems arise.

What you need

There are four forms of Acrobat software most comonly used. Acrobat Reader, is a free preview application which allows you access to a read-only version of a PDF document either in a standalone application or as an internet browser plug-in. Acrobat Standard and Acrobat Professional provide comprehensive tools for making direct PDFs in native Adobe applications. They also provide the virtual PDF Printer facility, for creating PDFs from most applications. Finally, Acrobat Distiller is used to convert a range of other formats, including Postscript files, into PDF.

Online distillers

Adobe have licensed the PDF format to third-party software companies, many of whom provide a cheap online PDF-creating service, although these services are more suitable for making office document PDFs.

PDF workflow tips

As with best-practice workflow for image processing, there's a string of do's and don't for preparing PDFs for the printing press. At the top of ths list is maintaining the quality of your assets until they are exported. Do this by ensuring your colour management is consistent between Photoshop and InDesign. Use TIFFs rather than JPEGs in your design document layout, as these won't be degraded from double-compression. Always embed the fonts in your final file, or they will be substituted without your input. Also avoid using free fonts, or any font from an unreliable source, as these may not scale or convert properly.

Export presets

You can package to PDF by a straight Export command within InDesign, where you can access the Export Presets and define the specific kind of PDF you want to make. Choose the Press Quality option for making photobooks. Your photobook printer may alternatively specify one of the ISO-verified PDF/X file formats, which are available as presets for you to create.

Most printers, however, prefer to re-jig your submitted PDF through a series of checks to ensure your file meets the requirements of the press. To avoid any unncessary changes, it's always a good idea to get as much information as possible from your printer beforehand. If in doubt, don't do it.

Proof with PDF

A good idea is to use the Export to PDF
command as a way of producing a no-cost
electronic proof. Any problems with fonts,
low-resolution images, image placement or
graphic files will immediately stand out in
the PDF. If problems occur, you can easily
return to the DTP document and fix them.

Using PhotoBook Proofer

PhotoBook Proofer is designed to show you how colour is translated from original files and documents through to the printed page of your photobook.

PhotoBook Proofer

To identify the significant reproduction issues before you commit your book to your chosen press, it is well worth considering the use of the innovative PhotoBook Proofer.

PhotoBook Proofer is a ready-made sample book that can be bought from all the major on-demand book storefronts and is available in all the popular sizes. It allows you to sample the quality of a printed book from a service provider and shows you, on a printed page, the way colour, tone and other important aspects of reproduction translate and how they are best prepared to suit that particular supplier's press and workflow.

PhotoBook Proofer contents

With so many process variables and largely hidden transformations applied by your service provider, it's important to see precise results from a wide variety of artwork before you spend time and effort on your publishing project.

In each section of the Proofer, artwork has been reproduced in a range of different ways so you can see what works best. Each image is labelled with a clear description of its origins and preparation sequence, so you can easily reproduce the workflow.

Colour workspace, (as shown above); contrast, colour saturation, sharpness, tints, overall image brightness and image resolution all feature as page tests.

Do-it-yourself e-version

As many service providers don't have a shopfront for selling books, PhotoBook Proofer is also available in an e-version as a press-ready PDF file, for you to submit directly to your own chosen provider, or as a series of image files to paste into your chosen book-template application.

Shown right, is a sample page from PhotoBook, displaying four different versions of the same image. Each has been produced with different Levels midtone adjustments.

Weblink

www.timdaly.com

Family holidays were never
quite the same without
Uncle Bob and his Box Brownie.

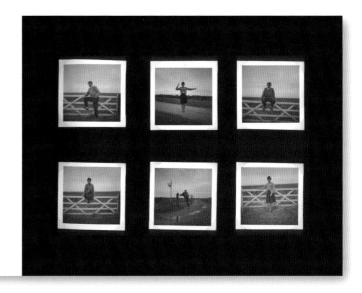

Chapter 5
Layout styles

···⟩ Pictures on a page

···⟩ Full-bleed layout

···⟩ Photo-documentary style

···⟩ Visual journal and blog book

···⟩ Baby and family albums

···⟩ Holiday album

···⟩ Wedding album

···⟩ Family history

···⟩ Vintage style

···⟩ Masks and stencils

Pictures on a page

Arranging even single images on a double-page spread can seem like a tricky proposition at first, but it always pays to experiment and to try out several different variations.

Photographic composition

Most photographers are masters of in-camera composition, but generally get twitchy when faced with the similar task of positioning images on a blank page.

The best way of getting past this initial hesitation is to accept that the picture on the page and the final exhibition print on the gallery wall are two entirely different things. An exhibition print is made to be viewed in isolation, an image in a book is part of a larger whole, so it pays to play around with different compositions and arrangements.

Page layouts need to look dynamic, visually arresting and stop casual readers dead in their tracks.

Breaking the rules

With many strongly composed and well observed images, the temptation is to reproduce the image in its entirety, uncropped, as in example at bottom right.

However, just because an image is successful, there is no rule that says there can't be another great crop lurking within. Two alternative treatments of the same image are shown above and top right, each offering something new and challenging to look at. The layout which displays the version looking most like a finished photographic print is perhaps the weakest.

Place-holder boxes

Book-design template software often forces you into decisions you'd really rather not make. Never squeeze an image horizontally or verically to fit a place-holder shape and never feel compelled to fill all the boxes in a layout if it feels like there are too many. White space in a layout is fine, especially if it helps to balance the contents of picture boxes.

The hardest templates to fill are the multi-panel pages, where perhaps nine different boxes need nine complementary images. It will really help if you settle on a template design first, then make a shooting list before the job begins.

Full-bleed layout

Based on the look and feel of magazine spreads and corporate literature, a full-bleed layout can create visually dynamic results.

Design considerations

Full-bleed layouts need to be planned carefully following the guidelines presented by your printer or service provider. Most template-based book-design software provides non-printing guides or lines to show you where to place your image edges, to take account of the production process.

All conventional and digital printing jobs specify that images and other design features which butt up to the page edge, must be enlarged (or bled) over the edge of the page to insure against the inaccuracies of the guillotine. If images are not fully bled over the edge, there is a strong chance that a thin white line will appear at the page edge after cutting. For the same reason, it is essential not to risk placing text too near the edge, lest some of it be trimmed off.

When enlarging images in page layout software, rather than in Photoshop, you need to be careful that you don't compromise image quality. Over-enlarged images will start to look pixellated when printed, but the quality can be much better if files are scaled-up first in Photoshop or a specialist application such as Genuine Fractals

Most template-based book-design applications like Booksmart have a useful warning symbol that appears if you over-stretch your images.

Pairs and combinations

Get your inspiration from fashion magazine spreads, often produced to provide a visual cocktail of many different ingredients, and see how different images are arranged side by side.

When planning to shoot such a project, always allow plenty of space around your main subject, on all four sides if possible, to allow maximum flexibility at the layout stage.

T.Scott Carlisle's book, *Little Things Big*, shown right, presents very different objects which appear side by side when the spread is opened out. Notice how the lines and shapes within the individual images start to arc back into the centre of the spread, effectively drawing your eyes around the layout and leading it back across the spine to the opposing image.

Less successful spreads are those where emphasis spills out from the edge of a page, stopping continuity altogether.

Placing images side by side in a page layout demands careful control at all times, so as to avoid white gaps between them. For a multi-image layout, pages need to be gridded up first with guidelines, so you remove any possibility of making a mistake. Never try to layout complex pages by eye and always use the rulers and the measuring tools available in your layout software.

Little Things Big by T.Scott Carlisle

This is a visually stunning photobook investigating the world of subjects in miniature. Packed full of images reproduced on both sides of the double-page spreads, unusual interpretations can be made from these clever juxtapositions.

Tiny and seemingly insignificant objects take on another layer of interest when scaled-up through the process of close-up photography and this can be further emphasised by the layout style. Reproduced as full pages and probably cropped slightly at the edges, the blow-ups really help to emphasise the subjects. Carlisle has also designed a really effective cover, below, using shading to pull attention away from the edges of the book and into the middle. Available to order through Blurb on www.blurb.com/bookstore/detail/159506

Photo-documentary style

When recording the innate character of a landscape or location, a sensitive layout style needs to be used in order to preserve the character of each individual image.

Evoking a sense of place

The very best documentary photobooks are designed to let the subject speak for itself, avoiding complex layouts and fussy typography. Many of the most important photobooks published since the Second World War, such as Cartier-Bresson's *The Decisive Moment* and *The Europeans,* reflect the dominance of the images themselves over type and text considerations.

Cartier-Bresson's books, like his photographic prints, display all his images uncropped and in full-frame. The format of 14"x10", unusual in itself, reflected the need to provide the right shape to present prints made from scaled-up 36x24mm negatives. The layout style of his books closely mimics a personalised album of prints, where you are guided through the story by the evocative images rather than directed by a storyboard kind of layout.

The translation of your hard-won images into a sensitively styled book can be made much simpler by deciding on the right book format from the outset. If most of your images are in the horizontal or landscape format, then the choice is already made for you.

Square-format books offer an ideal way to present a mixture of both portrait and landscape format images side by side at the same reproduction size.

Visual emphasis

Just like the careful balancing of landscape elements when shooting on location, the methods of laying out your work on a page are entirely based on composition. For many pages, a deep white border can be used to provide a barrier between the edge of the book and the edge of the photographic image.

Just like mounting a photographic print in a frame, extra space around the image helps to create necessary emphasis. When laying out your images, avoid the 'big is best' option. If you have spent a long time composing your work in the shooting phase, there's no need to recompose it again on the page layout.

Great documentary projects show their subjects off through an in-depth examination of environment, people and their artefacts. Classic projects such as Walker Evans images taken during the American Depression, show humble possessions alongside striking portraits. The cumulative effect of this mixture is best experienced through the book form, allowing you to navigate in your own personal manner and draw your own conclusions.

If captions are to be used, and there's not always a good reason to do so, they should be carefully thought through, so as not to spoil the experience of interpreting the image.

Bethlehem Steel by Shaun O'Boyle

This is an excellent photobook, shown below and right, which documents the atmospheric setting of an old steel mill. O'Boyle has recorded a wide range of subjects from different shooting positions, both close and wide, to create a richly varied set of images. The project is further enhanced by the simple layout style, where images are surrounded by a supporting white boder.

Page layout compostion works in exactly the same way as in-camera composition, where the arrangement of different elements can be based on simple rules of symmetry. Spreads from Shaun O'Boyle's book show a clever use of different templates including a 3x3 grid to present nine details from the project on a single page.

Bethlehem Steel, below, is available to buy through the Blurb online bookstore, on www.blurb.com/bookstore/detail/156924

Visual journal and blog book

It's easy to re-use your images to make personal photobooks, desktop prints and websites, especially if your work is stored on a social utility site like Flikr or Picasa.

Blog and visual reference books

Photobook service provider Blurb offers a clever way of recycling your online content into a blog book. Acknowledging that many new users of digital photography now have an entirely online workflow, Blurb provides smart links between itself and the major social utility sites.

This allows you to transfer images across your password-protected spaces without the bother of downloading and uploading again.

Blog books are a relatively new phenomenon which take the form of a words-and-pictures diary or a pictures-only product. Less concerned with the finely finished article, simple visual diaries are a very useful tool for practising artists and photographers. A visual diary should be treated like a sketchbook rather than a polished and edited photobook. Used to record different ways of exploring a subject or shooting techniques, they keep your creative ideas ticking over and can easily develop into new ways of making images

If you store your experimental work on a utlity site like Picasa or Flickr, you can easily transfer a stack of images across to a photobook site and autoflow into a preset page template. A good way of creating closure and an easy way to produce your own visual reference book.

Assembly methods

Working with a large volume of images can be time-consuming if you take the decision to edit the work down into a smaller collection. However, if you decide to be unselective and include everything, warts and all, the results can be just as interesting.

By including the entire batch of images from a project or period of time, you are effectively making readers responsible for editing the work and, most importantly, allowing them to construct their own individual interpretations.

There's little point in painstakingly arranging each image into a separate place-holder in your book template application, much better to harness some of Photoshop's automatic printing functions instead.

Multiple image layouts can also be time-consuming to assemble and fraught with difficulty if accurate measurement isn't your thing. Found under the Automated menu, Photoshop's Contact Sheet dialog box can be set up to create a custom-sized document which matches the size of your chosen book format.

Nominate the source folder for your project and then set up the distribution of images across your chosen page, then press OK. A similar automated function is available to produce a ready-to-load web gallery all from the same desktop source.

640x480 by Michal Daniel

An intriguing photographic project using low-resolution images taken with an Eyemodule2 digital camera. Photographer Michal Daniel used the camera plugged into his hand-held electronic organiser and was able to shoot a wide range of subjects without being observed.

As the name suggests, the images are captured in the now historic image resolution of 640x480 pixels per inch. Daniel gives a clue to his method of working:

'Standing on any street corner, stylus in one hand, staring down at the organizer in the other, I can silently make snap after snap, yet to most people I simply project – "Don't mind me, just organizing here."'

The images are presented in a grid format, as shown right, in both book format and on a separate website, providing a kind of stream of visual consciousness.

Seen in isolation, many of the images are throw-away, but collectively they build up a unique record of an observed urban landscape.

The page design is a simple 9x9 grid, replicating exactly the same layout on Daniel's website.

Weblinks

www.blurb.com/user/Michal
www.640x480.net

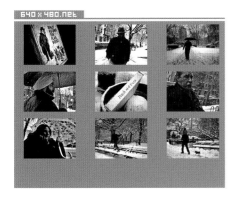

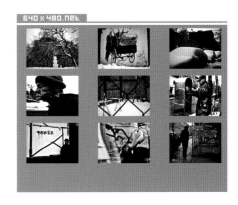

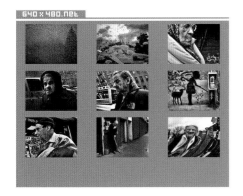

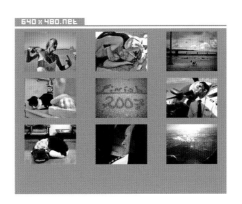

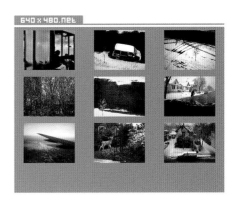

Baby and family albums

There's no reason to adopt the traditional family album format when you can easily make a photobook about a special event instead.

Celebrating family milestones

Traditionally, only the important dates were commemorated with a family photograph and many of these ended up jumbled together in a scrapbook type album.

Nowadays, the low production costs of a photobook enable us all to celebrate the smallest stages in a developing family history such as a year in the life of your child, the first week in a new house or even a special family day out. Photobooks have a finite size and extent and are ideally suited to recording the passage of time or a snapshot from the life of a special person.

There's simply no reason to file your digital pictures away when a selection of the best can be made into a memorable book for everyone to share. Start off by researching the kind of book you like the look of before you shoot your project, this will give you an idea of how much material you need and also whether it's going to be best to shoot landscape or portrait.

When shooting for your project, don't just search for the single iconic images that ordinarily would make great prints, but seek out and collect smaller details and scene-setters to give the photo-story some texture and provide background information. These smaller and quieter images can then be woven into the layout to complement your stronger images.

Small-format books

The smallest of the common photobook sizes are an ideal medium for presenting an informal but well observed study of a family member. The example shown above is produced by Bobbooks and has a stylish and hardwearing photowrap cover.

At such a small size, you can experiment with full-bleed layouts without any danger of over-enlarging your original file to fit the page. There's no need to have hundreds of images ready prepared either; twenty would be sufficient to start with.

Remember the dates

Even the most insignificant fact can add a further dimension to your family photobook when used as a caption or as a piece of text alongside your images.

These two examples right, show a traditional coloured layout, top, and a cleaner more contemporary layout style below.

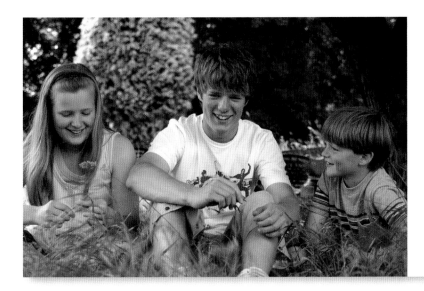

Dodleston

June 2008

Holiday album

Avoid the tired old photo opportunities taken in all the clichéed locations, the holiday photobook should capture the very essence of your family's experience.

Break from clipart templates

Although convenient and easy to use, simple clipart templates all start to look the same after a while. If you want to make a unique record of your family holiday, then consider using a service that allows you the flexibility to choose and customise your own artwork. Many template designs will date really quickly, freezing your photographs in a kind of time capsule.

Share the shooting duties

Online photobook providers offer an ideal way for your extended family to contribute to the making of the book. Unlike other services which provide downloadable software for use offline, online photolab Photobox provides template software that works in your browser.

After uploading images to a private storage area within Photobox, a book project can be started, stored and ordered online. You can even grant access to others to contribute to the process, all through the convenience of the Internet.

Humour works

Very rarely do you need to capture a flawless image to convey the enjoyment, humour or atmosphere in a shared situation.

Mostly, any image that recalls a humorous incident will trigger memories among your family and friends, so it's important sometimes to go for humour, even at the expense of technical perfection. This example above was bravely taken while confronting an over-aggressive goose.

Photobox books

The photobook example shown above and right was made using the online Photobox service. The book was designed with a full- bleed image on a wraparound cover and a line of text to accompany it.

The layout templates, shown right, are simple and stylish designs that provide a range of options for assembling a book.

Weblink

www.photobox.co.uk

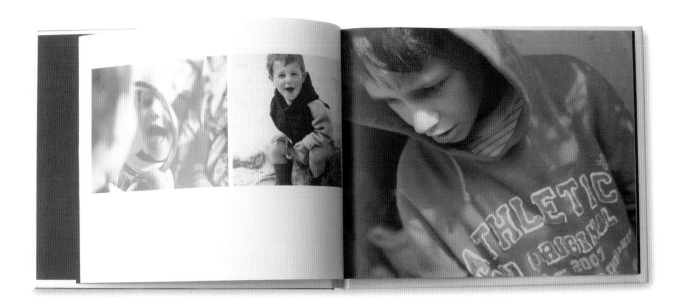

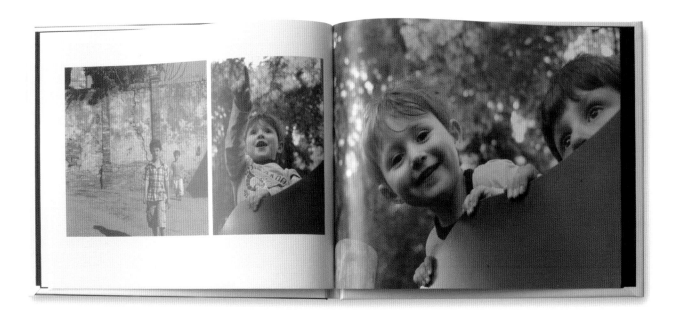

Wedding album

Some of the first to embrace the commercial and creative possibilities of the photobook were the wedding photographers.

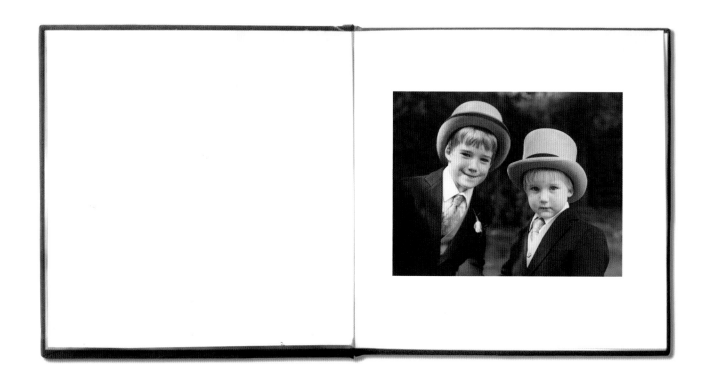

Traditional style

Conventional wedding photography is posed, carefully stage managed and paced slowly but surely to cover the day's proceedings. The subsequent images are classically presented in big white sheet albums.

It's still perfectly possible to create a traditional album feel using photobook template software, as shown above, but to maintain the traditional feel you will have to use expensive bindings such as linen hard covers or leather.

Contemporary

Shot and styled like a series of magazine spreads, the reportage treatment can make a really eye-catching photobook. In this approach, many individual images are created which provide plenty of visual material to lay out.

This example, shown right, has been made using an effective mixture of monochrome and colour images in the same album. The portrait format also permits a wide range of layout styles from full-bleed to smaller, more considered details.

Bobbooks

Bobbooks provides a stylish set of formats, finishes and sizes, as shown right. Bound in a wraparound cover finished with a matt coating, the completed book looks highly professional and indistinguishable from the lifestyle books found on many a coffee table.

Weblink

www.bobbooks.co.uk

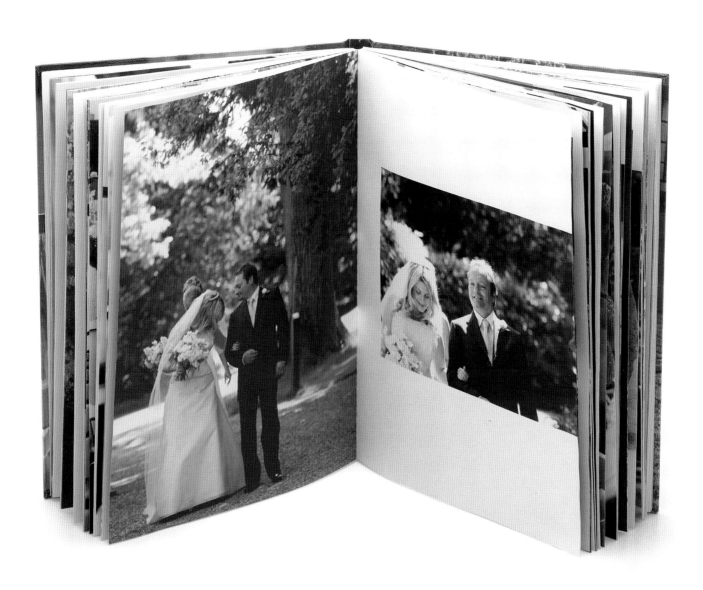

Family history

Photobooks are an ideal way to preserve your family heritage and, for the first time, they enable every member of your extended family to share the enjoyment of a rare photo album.

One-off prints and rare albums

A photobook can be the saviour of a family stuck in an ownership battle over a rare photographic heirloom. Despite the reproducible nature of silver-based photography, many family albums were one-offs and difficult to share without breaking them apart.

However, with the help of a simple flatbed scanner and some sensitive design skills, most family albums can be scanned and recreated as a brand new photobook.

All the elements which give an album its character can be scanned and re-assembled, including period photocorners, white borders and handwritten captions. Other non-photographic elements can also be integrated into a new photobook design, such as personal documents, passport pages and letters, to create an entirely new account of a person's life. Best of all, the new family photobook is easily distributed to the four corners of the globe.

Maintaining a period feel

It would make no sense at all to scan and digitally cut vintage images away from their album backgrounds, unless they were damaged and visually distracting. A much better idea is to try and preserve the original layout, borders and even the album's page colour in your new photobook design.

This example above, is a scan of a humble snapshot album, complete with mottled, midtone pages and stylish slit-corners to slide the prints into.

Both image colour and album texture could easily be sampled in Photoshop and restored to the digital version, so your new photobook is an accurate reproduction of the original. The slightly skewed position of the images, too, can be used in your layout to give the photobook its own individual character.

The sample page layout, shown far right, captures the feel of an early fifties family album with sensitive colouring.

Digital scrapbooking

Assembling hand-made albums, pages and journals from a mixture of different papers, frames and borders is called scrapbooking. Components are available in most big craft shops and there are also numerous collections of digital scrapbook assets to be found on the Internet, much like craft-style clip art.

Scrapbooking assets can be used to create photobook page layouts reflecting a unique period or era.

Shown above is a simple scrapbook page image complete with photo-corners and perforated edges, ready to fill with photographic images.

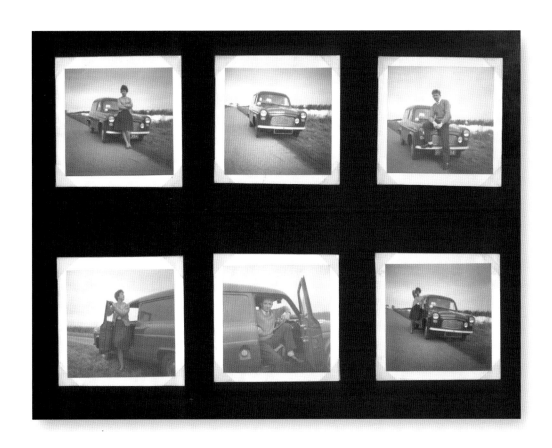

Vintage style

Many Victorian and Edwardian photograph albums, complete with decorative mounts can easily be scanned and used in a contemporary photobook.

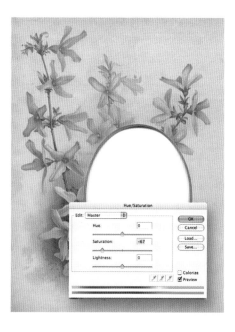

Scanning in source material

The example above was created using a loose mount taken from a Victorian photograph album. The design, which once provided the decorative surround to a family portrait, can still be re-used after scanning carefully in a flatbed device.

Start by positioning the mount on the platen and capture in RGB mode at at least 600 ppi. This printed example was still in good condition at the point of scanning and had a cleanly cut, bevelled, oval aperture. After scanning it would be used to frame a new portrait in a family photobook.

Although many vintage papers, mounts and album pages have suffered physical damage over the years, this is relatively straightforward to fix. Using Photoshop's Clone Stamp tool even the most severe rips can be made to disappear, so you can afford to consider less than perfect samples.

Repairing damage

This example mount above, had some visible blotches on the cream areas of the digital file, but these were easily removed with Photoshop's Clone Stamp tool.

Any other imperfections should be removed at this first editing stage and distracting or complex patterns can even be removed entirely. It's not important to arrive at a fathful copy of the original but to prepare a new version of the artwork that will best suit the new subject.

Use the Burn and Dodge tools to darken and lighten areas that look a little flat, in order to add more contrast to the mount.

Adjusting colour to suit

Although this example was in good condition, the overall yellow colour was removed, so it didn't overshadow the delicate colours in the modern portrait. To reduce or remove colour entirely use Photoshop's Hue/Saturation controls, as shown above.

Simply slide the Saturation control to a new negative value until the original bright colours drain away. The final piece, as shown right, had the new portrait pasted into the empy aperture, providing a much-needed crop to eliminate some unwanted background detail.

Masks and stencils

A pre-prepared page layout is an ideal way to frame several different images on the same spread and can even help you get the best out of slightly weaker images.

Recomposing your shoot

This kind of layout is an ideal way to crop unwanted areas out of people-based images, especially those which would not benefit from printing full-frame. Informal portraits need to be shot with great attention to detail, in particular keeping background information to a minimum through a shallow depth of field; however, many a good shot is still ruined by something very minor in the frame.

This layout example was made using a downloadable Photoshop template bought from the microstock site iStockphoto.com. The template is made using seven old Polariod instant prints, pinned against a neutral background to provide you with a series of frames to fill with your images.

The square, bordered frames enable you to recompose your original images, squeezing rectangular images shot in both portrait and landscape format, into a new square composition. The new shape creates a completely different end-result.

Free paths

Good quality templates usually contain prepared masks for you to use straight away. This example image was supplied with seven paths, as shown above, one for each of the blacked-out print centres. Paths are simple vector outline shapes that can be saved with an image, contributing very little data to the overall size. Paths, of course, can be made into selections, which in turn form the masks to hold the images.

Mask layers and Paste Into

Assembling the final page layout is simple. First, in the Paths palette, convert a path into a selection then import your chosen image by doing Edit---->Paste Into. This command will send the image behind the selection, allowing you to recompose and enlarge/reduce it. Shown above is the layers palette for the project. Shown top right is the blank starting point and below the finished page layout.

Chapter 6
Type and page design

···⟩ Type essentials

···⟩ Fonts and font families

···⟩ Photo covers

···⟩ Captions

···⟩ Traditional papers

···⟩ Solid colours and tints

···⟩ Contemporary graphics

···⟩ Paper tones and textures

Type essentials

Clumsy type styling and poor attention to detail will distract your readers from the real purpose of your photobooks.

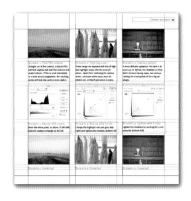

Leading is the vertical distance between each line of text. When set at 1.5x the type size, it will help legibility.

Size and measurements

All computer-generated type is constructed from vector outline shapes rather than pixels, making it easily scalable and requiring lesser digital data. Type is measured on a points scale, rooted in the bygone days of cast metal type used in letterpress printing,

The point scale is unlike any metric or imperial scale we use in day-to-day life, but is easy to pick up and use. The standard measurement is x-height, (the height of a lower-case x) and, as a guide, a 72-point character has an x-height of one inch.

Most printed matter that we read in books, magazines and journals ranges from 8- to 10-point in size and we generally write word processing documents in the slightly larger 12-point. Surprisingly, over-large lettering is just as difficult to read as small lettering and the choice of font can have a profound effect on legibility, too.

Grids and master pages

All professionally produced printed matter using large amounts of text is designed to fit a pre-determined grid. Invisible after completion; the grid provides a coherent template for flowing text into columns in a multi-page document in a consistent manner.

Grids subdivide the page or spread into geometric shapes and sections, and also provide guidelines for sizing imported images or graphics. Within the grid itself, text information can be arranged and subdivided into readable chunks.

A grid design is established at the start of a DTP layout project, when page size, number of columns, margin size etc are determined. This template can then be made into a master page, effectively a resident blank spread on which all subsequent new pages will be based. The master page can also incorporate commonly recurring elements, like page numbers.

Spacing and leading

Good typography allows information to flow effortlessly from the page to the reader. Making your books legible is not just about choosing a nice font, it's about getting all the ingredients and measurements in proportion. In many instances, it's the amount of empty space around words and images that determines legibility rather than size alone.

After type size, the most important thing to get right is the leading (pronounced ledding), which determines the space between lines of text. Leading is generally expressed as the size of the type and the depth of the line it is set on (i.e. the type plus the leading). So this column is set in 9 point on 13 point, i.e it has 4 points of leading. In DTP applications, leading values are always expressed as a single figure, combining both type size and line depth.

This example of poor typography assumes that the reader will be able to follow a long, horizontal string of letter from one side of the page to the other. In fact, it has long been proven that long lines make it extremely difficult to maintain focus and easy to lose one's place on the printed page. Although this may appear to be a convenient way to distribute information on a page, it will lead to your text remaining largely unread. Tiny text that is spread over a column that is too wide would further complicate the issue. A sensible compromise is to base your grid on a range of 38-55 characters per column width, as good practice is more about proportion than just size.

If type is over-enlarged, it becomes difficult to read due to individual letters on other lines starting to interfere with with the process of reading. Is this due to type size alone or caused by tight leading?

14pt text with 14pt leading, 20-24 character column width

Shouting loudly never made anybody listen. If all your text is set in bold, the emphasis effect is lost and you can't see the wood for the trees. Never use bold for body copy.

Blocks of text which are justified, (i.e. the spacing between words is adjusted so all the lines have the same length) are easy to place and arrange in your layout. They can be positioned in a simple symmetrical page layout, perhaps mirroring the position of your image on the opposite side of the spread. Always avoid too few characters on a single line as this becomes d i f f i c u l t to read.

If type size, leading and column width are in proportion, blocks of text are much easier to read. Plenty of space around your characters allows readers to focus on each word and make sense of the information you are presenting.

14pt text with 21pt leading, 38-40 character column width

Fonts and font families

Fonts are like clothes used to dress up words for public consumption. Choose the wrong style and your photobook will look horribly old-fashioned, or worse still, completely unnoticeable.

Sp **Sp**

Seriffed fonts

This kind of letterform is designed with small embellishments at the ends of letter shapes, called serifs, which help to guide your eye from one letter to the next. When reading words created with seriffed fonts, there's less of a visual gap between adjoining characters.

Seriffed fonts are the best to use for laying out large areas of copy and are mostly used in books, newspapers and magazines. The most commonly used seriffed font is Times, which is found as part of every computer system font pack.

Conversely, seriffed fonts are difficult to read when used at larger sizes and would take longer to read and digest if used for signage.

Sans-serif fonts

The sans-serif form is a more recent invention and is generally used for headings, headlines and signage. Quick to read when displayed at a large scale, sans-serif fonts have a more modern feel compared to seriffed fonts.

Sans-serif type is quick to read and grabs your attention and is ideal for chapter headings, section starts and sub-headings.

Despite this general rule, many books and magazines use lighter weights of sans-serif for body copy. These thinner variants are easy to read provided that they are set with plenty of space around them.

The most common sans-serif fonts are Arial and Helvetica, both normally found as part of a computer's system fonts.

Script fonts

Script fonts have their roots in hand-rendered calligraphic letter-forms and provide an elegant vehicle for conveying information.

Scripts are generally used as decorative rather than functional elements on the printed page and are completely unsuited for large blocks of text.

With swirly lines and over-complicated flourishes, type set in a script font takes ages to read and assimilate, so should be used with caution.

As with all type faces, script fonts are riddled with associations and stereotyped over-use. Just because you last saw it on a wedding reception menu, there's no good reason to style your wedding photobook with the same font.

abcdefghijklm
abcdefghijklm
abcdefghijklm
abcdefghijklm
abcdefghijklm

meta plus normal

meta plus bold

meta plus black

Font families

Just because your computer is loaded with fifty fonts, you don't have to use them all at once. A much better approach for a photobook is to limit your type range to a single font family, as shown above.

A font family is a specially designed set of interrelated versions of the same font, called weights. A typical family may consist of the following variations: normal, bold, italic, black (even thicker than bold) and condensed (thinner than normal).

These variations provide sufficient variety for you to create headings, text, captions and book cover designs. Using a font family to create a consistent style throughout your book is a very smart idea and stops you having to worry about picking the wrong combinations from the outset.

It is much better to actually change the font, from say the normal to the italic version, of a family rather than using the software-driven character modifiers such as bold or italics, as found in word-processing and DTP packages. These commands can sometimes translate incorrectly on the press, so it's much better to use the real thing.

Style sheets

Selecting and formatting text to comply with your chosen design style is a time-consuming activity. A much better idea is to create a style sheet in your DTP application which can apply a formatting preset at the click of a mouse.

Style sheets are essentially pre-made type formatting that is applied to a long book or document to ensure that human error is minimised and a consistency is achieved from cover to cover. Documents created without a style sheet can look amateurish and confused.

A good style sheet for a photobook project would include different styles for title page, chapter opener, one or more categories of heading, body text and captions. Once you have established which fonts you will use, their size, leading and colour, this 'recipe' forms the individual saved style.

Style sheets are also an advantage if you decide to make wholesale changes to your document halfway through your project. Once a recipe style has been set, then every instance of a particular element in your project can be updated automatically with the new style, using a single command.

Pre-flight practicalities

Like any other design, fonts are copyright-protected and must be licensed from a font reseller. Although there are plenty of copyright-free fonts to be found, by scouring the Internet, it's best to stick with products that originate from a proper font foundry.

All fonts used in a design must be packaged up together with high-resolution image files and sent to your printer at the point of final delivery.

Both QuarkXpress and InDesign provide a pre-flight check, so you can see if all the digital assets for your layout project are available. Once the check is complete, both applications will collect all the contents up, effectively making duplicate copies of every image, graphic and font required, ready to deliver to your service provider.

If you are using a PDF workflow to deliver your final file, you must ensure that your fonts are embedded in the final document, otherwise different fonts will be substituted at the other end. This will turn your carefully designed layout into a jumble.

Photo covers

The easiest way to grab a prospective reader's attention is through an eye-catching cover design that incorporates both images and text.

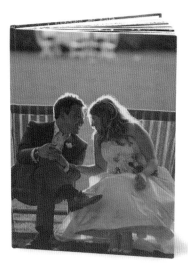

Paper laminated covers

Many of the better photobook service providers offer a high quality hardback option complete with a paper laminated cover which is glued to the boards. This example, shown above, from Bobbooks, uses a high gloss finish over a photographic image that has been fully bled across both front and rear covers.

Unlike conventional dust jackets, images used in this manner need to extend about 1cm around all four edges so they can be folded around the boards and tucked under the endpapers.

More permanent than soft-backed books and less prone to damage than removable dust jacket, laminated covers are ideal for wedding books and family albums.

Dust covers and jackets

A dynamic way to communicate the contents of your title on the cover is to assemble a smaller selection of images into a grid. Pamela Clarkson's cover for *Lorem Ipsum: An exploration of self through context*, creates a nice visual taster.

The cover was created using a simple dust jacket template in Blurb's free book-design software, Booksmart. By using a rigid template format, it's possible to recompose individual images into smaller chunks, thereby giving only a taster of the contents within. The final portion of the image remaining visible in the template could even be an insignificant element of the original image.

Photobook cover designs

Distilling the essence of a book in an image or two and a few chosen words can be a very difficult proposition. However, get the balance right and your design can immediately send the right signals to your potential purchasers.

Shown right are nine very different book cover designs, each successful in its own way. Top left shows T. Scott Carlisle's excellent use of wood block-like type to make a bold visual statement in his New York book. Next along the top row is Jessica Kaufman's *Panopticon* cover, designed simply to show off the inner content. Top right is the *Little Things Big* book by T.Scott Carlisle, using an effective coloured type positioned over an empty space in the frame.

In the centre row, the first two designs use images of a face to grab your attention, especially Luke Turner's *Portrait* book. Far right shows the eye-catching graphic work of Robert Mars, combining bright colours and collage.

In the bottom row, Kerry Pitt-Hart's cover for *I spy* is a playful image of shapes from the opening spread of a book. In the centre, *Bethlehem Steel* by Shaun O'Boyle, cleverly weaves letters into the facade of the book's subject. Finally, Wiliam Collins' *Rucksack Accessories* travelogue grabs your attention with bright colour and a clever use of silhouette.

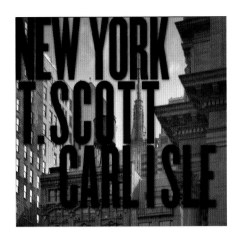

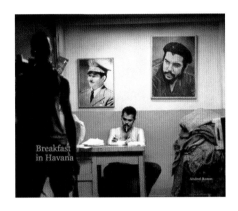

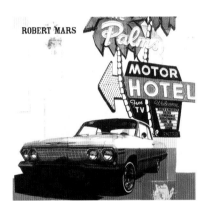

Captions

A sensitive layout can easily be spoiled by a caption that's been written clumsily, or one that's been designed using the wrong mix of fonts.

New Brighton, 1988

Silver gelatin print

New Brighton, 1988

Silver gelatin print

Caption writing essentials

Captions are never compulsory in your photobook, they should only be included if you think there is additional information about the subject that would contribute to the reader's experience.

Dates, locations, names of people, details of events are all acceptable, providing they are kept short and to the point. A sparse line of text can also be used to reveal any subtext to the images, especially if the real message is invisible.

Never use a caption to repeat what's obvious from looking at the image; never try and elevate the importance of your images with a poetic equivalent (especially in French!) and never list the camera settings used to capture your prey, or your images will seem like hunting trophies.

Emphasis essentials

Once you have decided to use captions, then it's important to place them far enough away from your image in the spread. The trick is to make them as small as possible, but still legible, and to vary the type style enough to allow different parts of the information you are using to stand out.

Captions are best applied in a place-holder which is set in the same position on each page. Most photobook template software provides this facility, but to achieve the same result with a DTP application, a master page first needs to be created. Consistency in type colour and style and colour throughout is an essential.

Above right shows a poorly chosen script font which is difficult to read, and on the left, an example of emphasis placed on the wrong line of the caption.

Using font families

Designing captions with a specific font family is much easier than trying to work out a pleasing combination of different emphasis effects. Shown right are three horizontal sets of captions, each made with a different font family

The top row shows three caption designs made with Meta, a stylish sans-serif font. Left to right: Meta bold, Meta bold at 50% and Meta normal. Although the normal version is easiest to read, all three lack sufficient variation to be successful.

The middle row displays three designs made with Sabon, a seriffed font. On the left is Sabon roman on the top line with Sabon italic underneath; in the middle is Sabon small caps on the top line with Sabon italic underneath. On the right is Sabon bold with Sabon italic underneath. All three work much better than the Meta variations, with the middle combination looking best.

The bottom row is made with Perpetua, a font with calligraphic overtones, originally designed by Eric Gill. On the left is Perpetua italic bold on top with Perpetua italic underneath. In the middle is Perpetua black with Perpetua italic underneath and on the right is the best of the three designs: Perpetua normal with Perpetua italic underneath.

24

New Brighton, 1988

24

New Brighton, 1988

24

New Brighton, 1988

New Brighton, 1988

Silver gelatin print

New Brighton, 1988

Silver gelatin print

New Brighton, 1988

Silver gelatin print

New Brighton, 1988

Silver gelatin print

New Brighton, 1988

Silver gelatin print

New Brighton, 1988

Silver gelatin print

Traditional papers

If you want to evoke a period style or mimic the look of a traditional book, consider using decorative endpapers and panels.

Book options

Digital photobooks do not usually offer the facility to choose an endpaper design, or to incorporate one into the production. Most hard back digital books are printed and bound using a non-negotiable plain white endpaper attached to the cover boards.

Only hand bound books offer the option of adding a decorative paper to your project, but the results can be very impressive.

Patterned panels

An alternative to leaving the left-hand page facing an image white, or printing it with a coloured tint, is to use a patterned panel, as shown above. This was created from a sheet of hand-printed paper, which was first scanned and then modified in Photoshop.

Specific patterns or designs could also be used to suggest an overall theme, era or treatment and could really help to set your photobook apart from those created using stock templates and artwork.

Scanning line art

If your chosen artwork is line art, i.e it consists of black and white only, and most importantly no other tones, you'll get much better results if you scan it in the bitmap image mode. If you make a scan at 1200 ppi, the bitmap can be opened and resized according to the size you need to use it on your page. If any colour is present in your original, such as in the example shown above, best results are gained when it is scanned in the RGB mode.

Marbling and montage

Endpapers are the folded sheets that attach the cover boards to the block of inside pages of a hardback book. Shown above is a marbled endpaper made with good quality cartridge paper and simple marbling inks.

Decorative papers can also be used as chapter or section openers, or to act as a visual counterbalance to an image on the opposite side of the spread. This example, shown left, was assembled in template sofware using a scanned scrap of paper from an old diary.

Solid colours and tints

There's no good reason why all the pages in your photobook have to be white. Choose a subtle colour to complement the rich tones in your image.

Template colours and tints

Most design template software has a small number of tints that can easily be applied to your pages. Better software allows you to create custom colours that fit in with your project, using the universal 0-255 RGB scale. Even greater control is available in a DTP application, where you can also tint your colours using the 0-100% scale.

Making custom tints

All image colours can be sampled in Photoshop, by using the Eyedropper tool combined with the Color Picker, as shown right. Simply click onto the image colour you want to use as a tint and the Color Picker will detect the precise RGB value, as shown in the blue box. This can then be entered into your template software as a custom colour.

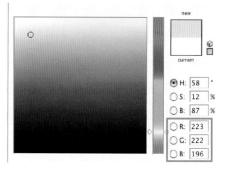

Black and midtone tints

In Josh Ballan's photobook *Urban Ugly*, shown above, pure black pages were used on both halves of the spread. Black can look really striking when used with muted colour images, allowing subtle hues to emerge.

When laying out toned monochrome images, as shown left, consider sampling a midtone colour from the image and use this to fill the opposite page. The effect enhances the warm tone of the original.

Urban Ugly
www.blurb.com/user/ballan

Contemporary graphics

If you want to add decorative graphics to your layout there's plenty of low-cost, royalty-free stock images available for instant download.

Graphic panels on pages

Decorative illustrations can add a really stylish touch to your photobooks, especially if you want to break out of the confines of your template software.

Large patterned panels can add a feeling of luxury and relieve the monotony of blank white pages. Many contemporary photobooks, especially those containing portraits, include richly detailed graphics on the facing pages of the spread. The example shown above creates a similar effect to the tooled velvet panels in traditional daguerreotype cases.

The trick with using graphics is to choose subtly coloured designs and expecially those without visually demanding details. If you have the flexibility to scale the artwork on your page, go for bigger shapes rather than tiny details.

Using a microstock service

Although there are plentiful online collections of clip art and scrapbooking resources available for free, it's well worth sourcing repro-quality artwork from a microstock site such as iStockphoto.

Unlike other large image libraries, iStockphoto uses a low-cost pricing structure, making most of its images and illustrations affordable. With prices low as a couple of pounds per download, you could easily source a unique graphic file that will add an original touch to your project.

Images are costed on the basis of their resolution and usually supplied in the scalable EPS file format or as a JPEG, and both can be downloaded from the site straight away, ready to place in your project folder.

Working with vector artwork

Most graphics or illustrations, like the example above are created with vector drawing programmes like Illustrator and supplied in the universal EPS file format. Although you can open EPS files in Photoshop, you'll be forced to define a document resolution on opening and rasterize the vector file too.

A much better way of managing vector artwork is to open it in Illustrator and do any changes necessary. Within a vector-editing environment, all elements can be altered without losing resolution, colour or forcing delicate gradients to reproduce in bands.

Once editing has been completed, the file can be output as a flattened JPEG ready to load into your template or DTP application.

Paper tones and textures

It's a simple task to break the monotony of plain white pages in your photobook using a flatbed scanner and sheets of vintage textured paper.

Materials and images

We never think of changing the nature of the paper used in the printing of a photographic image or photobook. Yet this largely invisible layer can be manipulated to add another ingredient to your work.

No digital press prints on heavily textured papers, but it's a straightforward job to add an underlying texture, tone or colour to your background in Photoshop and output the result as a project-ready JPEG file.

If you want to add a bit of character to your pages, then consider scanning blank sheets of laid, bond or watercolour papers and build up a library of different colours, tones and textures. Another good option is to search out faded pages in old books or journals, as they can add a really interesting dimension to your layout.

After scanning, simply adjust the size to match your layout page and then copy and paste in your image file. Arrange your image over the background texture and then choose the Multiply blending mode in the Layers palette to make your photographic image take on all the underlying characteristics of the paper, warts and all.

The Multiply blending mode will create new highlight in your image too, making the overall effect look really convincing. Finally, flatten the layers, save as a high quality JPEG ready to load into your project folder.

Protecting coloured highlights

This original salt print, shown above, contained yellow highlights and would have lost its quality if laid out on a white page. The highlight yellow was sampled and set as the colour of the template page to create a visually gentler environment.

Vintage papers

The two examples shown right were made by combining a textured source image with an original colour image in Photoshop. The sheets of paper used were found at the scene of the shoot and so add a further dimension to the project.

Chapter 7
Alternative styles

····⟩ Inkjet printed books

····⟩ Hand-bound books

····⟩ Photo-emulsion books

····⟩ Personal journal

····⟩ The book as a journey

····⟩ Found photo-objects

····⟩ Instant prints

····⟩ The book as a collection

····⟩ Inkjet transfer book

Inkjet printed books

For one-off books or portfolios, there's no higher quality than an inkjet printed book. With a huge choice of papers and binding options to choose from, it's easy to launch a limited edition.

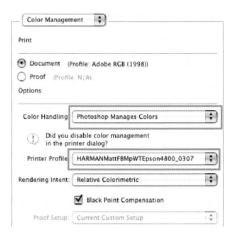

Paper choices

Paper manufacturers now provide double-sided versions of their inkjet paper, which provides the perfect media for bespoke book making. Both Innova and Hannemuehle produce cotton-rich papers that are coated on both sides and are flexible enough to withstand a crease. A3 sized sheets are best for printing double-page spreads which can then be folded into sections.

Books made in this way can be output on a good quality pigment inkjet, with the required profiles, to ensure a near-perfect quality of reproduction. Unlike print-on-demand books, these hand-made photobooks can be produced in a way that allows you to maintain maximum control over colour gamut, saturation and tone, but they are much more time-comsuming to print and assemble.

Printing directly from Photoshop

The easiest way to output your individual sheets or double-page spreads is to print them directly from Photoshop. After working out the paper size for your inkjet book, create a new document in Photoshop to match.

Prepare your chosen images individually, viewing them under the soft-proofing conditions for your chosen paper before editing. To ensure images are laid out consistently, use both rulers and guides to create place-holder boxes, this way you can be assured your images stay in the same place when printed.

The best way to manage the project is to apply edits through non-destructive Adjustment and Smart Layers, as shown above, so you have maximum flexibility to prepare your image for output.

Using printer software

To ensure you achieve the best possible print quality in your inkjet book, it's important to print with the downloadable paper manufacturer's profile, rather than using generic printer software settings.

When using a third-party profile to print with in Photoshop, it's essential to choose the right settings in your printer dialog box, or you will get unexpected results. When printing with profiles, it's Photoshop which determines how pixel colours are translated into ink droplets, not the printer software.

For this reason, you must select 'Photoshop manages colour' option, as shown above, in your Print dialog box as well as picking the profile that exactly matches the paper, ink and printer combination that you are currently using.

Working out the imposition

The most difficult aspect of planning your own hand printed photobook is working out the imposition. In the process of making a book, several sheets of paper are printed on both sides, folded and then interleaved to make a section with the correct page numbering.

The imposition of a simple photobook, with one image per double-page spread, can be difficult to visualise. It's essential therefore, to have a clear running order worked out before you start putting sheets of paper through your inkjet. A good idea, as shown above, is to make up a dummy section using blank paper, which is folded and then numbered, to show which image sits on which sheet. Then, take the dummy apart and you will have the running order worked out for you.

Grain direction

If you do decide to print and fold sheets of inkjet paper into book sections, avoid hard and shiny or baryta-type products as these will crack at the creases. The best kind of papers to use are the softer cotton papers.

During the manufacturing of high quality paper, liquid pulp containing tiny cotton fibres is aligned in one specific direction, which gives paper its inherent strength and rigidity. This gives each sheet a characteristic grain direction, found running parallel with the longest edge in most artists and fine quality inkjet papers. Grain is important to identify at the outset if you are assembling sheets into sections, as it should run parallel to the bottom edge of the book after collating. Never make sections with several sheets of paper where the grain runs in different directions

Cutting and trimming

Self-assembled inkjet books which are stitched together (see next page) need to be trimmed before a hard cover is attached. Although you may use pre-cut inkjet paper supplied in exactly the same size, when several pages are assembled into a section, the innermost sheets stick out furthest, or they lie slightly out of alignment.

Sections never lie exactly neatly together after sewing, so it's essential to have the entire book trimmed. Mark up the cutting line, measuring from the spine outwards first then setting the height. Take your book to a commercial printer and ask if they could guillotine the excess off. All mis-aligned page edges should be removed by the guillotine, leaving a perfectly crisp finish.

Hand-bound books

Printed inkjet sections are easily transformed into a hand-bound book, with patience, plenty of spare time and a minimum of specialist equipment.

Preparation

Lay out the individual prints and make a slight score along the line of the fold with the reverse side of a craft knife, being careful not to tear or cut the paper in any way. This score line will allow you to make a neat fold without creasing the paper.

The best tool to use to smooth the fold in the paper is a bone folder, a smooth, non-marking implement available from bookbinding suppliers. The bone folder will compress the fold of thick papers very well, allowing you to insert other pages easily into the section. The number of pages that you will be able to make into a section will really depend on the thickness and weight of the paper, but usually no more than four 200 gsm sheets should be made into a single section, otherwise the sheet in the middle will poke out too far. Much thinner papers can be made into bigger sections of course, but if you have used heavyweight paper, then your book should be constructed from several sections sewn together, rather than just one.

Assembling your book

For a simple binding, the pages of a single section are sewn together in a figure of eight loop. Start by pricking three holes with a darning needle into your section fold, going through all the individual sheets. Make a hole in the centre of the fold, then another two equidistant from the centre, but not closer to the edge than two centimetres. Start by inserting your needle in the bottom hole through the back of the section to the centre, leaving at least ten centimetres of thread hanging outside. Bring the needle back into the middle hole, then follow a figure of eight loop twice, before tying the end of the thread to the ten spare centimetres left outside from the start. This will now make your section sit tightly together.

Making the cover

To make a simple clothbound cover, you need to cut three pieces of card (thicker than mountboard), two for the front and back and a thinner strip to reinforce the spine. Ensure that the card extends at least a half-centimetre beyond the pages on the top, bottom and leading edges, but not on the spine edge. Make a sandwich of the cover cards and the printed sections,

then measure their combined thickness to determine the width of the piece of card for reinforcing the spine. This project was bound in a simple cloth cover, available at all bookbinding suppliers, providing a strong outer skin. Lay the card pieces onto the cloth, leaving half a centimetre gap either side of the spine strip, to provide a hinge for the front and back covers. Next cut the cloth around the cover boards leaving at least four centimetres extra around the edges for tucking in.

The next step can't really be rushed and must be left overnight at each gluing stage. Lay the cloth out on a newspaper and run a pencil around the position of the three cards. Remove the card and coat the marked-out areas of the cloth with PVA glue, then put the cards in place. At this stage the cover needs to be pressed and left to dry, best done in a nipping press, as shown right. Overnight, this will have dried and will now be ready for the next step. Coat the remaining cloth with PVA, fold the flaps over the boards, like wrapping up a present, and press into place with your bone folder. Press this stage overnight again to ensure that it all sticks together and remains flat. Rushing the gluing stage will create a warped cover.

Gluing the cover on

When the cover is ready, the section can be inserted to complete the project. Before this, two endpapers need to be attached to the front and back of the printed pages and the cover. Endpapers are best made from strong papers and need to be the same size as your printed pages (i.e. double-page width, scored and folded).

Make two endpapers, one for the front and one for the rear and check that they are the right size before sticking. Lay the endpaper out folded and apply PVA to a two-centimetre strip down the folded side. Next, press this onto the first page of your printed section to create a hinge. Repeat the process with the rear endpaper and leave overnight to dry. The final stage is to attach the cover to the endpapers by applying glue to one endpaper at a time, then gently pressing it against the inside of the cloth-covered card. When both ends have been glued, the book again needs to be pressed overnight to dry and flatten.

End result

The end result will be a tactile and unique volume, ready to enjoy. With its hand-made special cover and printed insides, this kind of book can't really be produced in any great quantity, but is an ideal way to create a one-off for exhibition. Although the binding process can seem complex, there is little specialised equipment needed to make a hand-made photobook and your results will get better with each effort. Another advantage of making your own books is that you are not limited by the format, size or shape of a commercial photobook service, so you can design and construct to fit your own plans.

Photo-emulsion books

Making digital negatives allows you to contact print your image onto specially sensitised art papers which can be easily bound up as a hand-made book.

Making digital negatives

Permajet's OHP Transfer film media is an ideal media to use. It's coated on one side and allows very fine detail together with plenty of ink, thereby creating a negative dense enough to use in the darkroom. It has a specially prepared ink-receiving layer made from fine ceramic particles, essentially designed to create 'pores' on the surface of the normally impervious media.

These pores allow the ink to be absorbed evenly and, most importantly, allow it to dry ready for use. Although the media emerges from the printer relatively dry, it's best to leave your digital negatives an hour before using in the darkroom, just to be on the safe side.

Preparing files for output

Inkjet negatives never provide the same level of sharp detail as a 5x4 sheet of monochrome film contact-printed onto photographic paper, so it is wise to accept the compromise from the outset. To counteract the slight loss of detail it is also a good idea to sharpen the image slightly more than you would do normally for a positive inkjet print.

Like those shot on transparency film, these negatives are destined for direct printing, so all creative burning and holding back has to be done in Photoshop, rather than in the darkroom.

Inverse or negative option

There are two ways of preparing a digital negative for output to a desktop printer, either inverting the image in Photoshop, as shown above, or using the Output-as-Negative option. To create a negative in Photoshop, ensure that your file is in the greyscale image mode, then apply an Invert Adjustment layer. The tonal values of your image are simply changed over, ready to output as usual on your desktop inkjet. The second alternative is to prepare your file as described, then in the Output

section of Photoshop's Print dialog box, select the Negative option. With this latter choice, you will notice that the printer will make the non-printing area of the media black, enclosing your image. While this is desirable if you want to achieve a crisp white edge around your print, it could also waste a lot of ink. A better method is to output onto cut A5 sheets of the media and leave about a centimetre between your image edge and the media edge. Inverting your image in Photoshop with an Adjustment layer will create a negative

printout on your clear media, surrounded by a transparent border. Like a conventional clear film base, if this is included in your darkroom print, it will create a black edge around your image. For this project, made in conjunction with liquid emulsion, I chose the Invert Adjustment layer option to show a black edge around the image and bring into play the brushy liquid emulsion edge.

Testing different densities

Like conventional monochrome film, inkjet negatives are best prepared with their eventual use in mind. Rather than creating a straight print as you would for output as a positive print, it's a good idea to experiment with different densities of the negative image, as shown above. The best way to do this is by using Photoshop's Levels commands to create gradually lighter versions (in the positive state) or

darker versions (in the inverted state). Additional density, or depth of black, will provide you with a slightly longer exposure time in the darkroom, perhaps buying you enough time to make a 10-second contact print exposure and a little burning-in if needed. The trick in this process is to make your negative as dense as possible without ruining sharp detail or collapsing highlight areas into solid white. To judge the ideal kind of negative, a test image file was prepared with three densities, each one created by moving the Levels midtone slider to create the difference.

In use, the denser variants proved much easier to print with, while printing from the uncorrected negatives was much the same as trying to print from an under-exposed negative. As much as a +30 change in the Levels mid-tone values will be needed to provide this additional density, but this

will vary with your individual image files. As important to the overall density of your specially prepared film is the thorny issue of contrast. To manage the transition from negative to print effectively when printing onto fixed grade emulsion (as is found with the liquid emulsion used for this project), it may be necessary to return from test printing to make a different negative at lower contrast. Rather than altering the contrast of your printing paper to suite the negative, the process is the opposite way round.

Using printer software

Permajet recommend using the highest specification media settings in your printer software dialog box, either the Photo Quality glossy film or the Glossy Paper Photo weight types. These media options command the printer to drop the finer 1440 dots per inch of ink on the media.

The media can be used with both dye-based and pigment inksets, but best results were gained when using the Epson 4800 equipped with a Black, Light Black and Light Light Black inkset configuration. The presence of these three different values of black really helped to provide a subtle tonal range on the negative that would otherwise be difficult to achieve with a single black ink.

Printer configuration

Despite the monochrome nature of the project (tri-colour separations would be an altogether different proposition), a range of results were gained when trying different printer settings. Opting to print with black ink only made the negatives appear granular and gritty, just like making a paper print with the black ink only setting. This kind of negative was high in contrast, too.

A softer alternative is to use the colour ink setting on your printer software, thereby using the printer's maximum resolution to make your negative for contact printing. Output using eight individual colours, rather than three, the negatives showed more fine detail and a softer contrast range overall. The film did emerge with an overall sepia colour, but this was not judged to be an issue when printing back onto monochrome paper (imagine XP2 negatives).

Working the negative

Unlike precious film originals, the inkjet negative is not unique and can be easily reproduced. This allows you free rein to modify the ink-receiving side of the media by scraping or scratching to create a unique surface texture. The ink won't respond to re-wetting, so you can't brush around the edge of your negative, but you can easily damage it with scalpel or sandpaper (not for the fainthearted!).

Working out the pagination

To create a simple book, eight sheets of paper were folded in half lengthways to provide sixteen sides in all. After creasing and assembling into a single section, a good idea is to number each of the sides with a pencil, so you can easily reference which image is to be placed on which page, not an easy thing to attempt on the fly! For larger books, multiple sections can be assembled and stitched together.

Coating your paper

For this project, several sheets of artist's cotton print-making paper were used, each coated in Silverprint's SE1 liquid emulsion. This kind of emulsion provides a rich tonal depth and is very simple to use. The emulsion arrives in a gel form, which needs to be first warmed gently in a water bath to change it into a liquid, usable form. Under safelighting, the emulsion was painted onto the paper with a soft brush, leaving some scratchy edges around the sides. The coated paper was dried using a hairdryer and then stored in an empty black and white paper box until ready for use. A good idea at this stage is to coat several thin strips of paper to use as test strips, so as not to waste the full sheets. After drying, the emulsion becomes invisible, so it's essential to mark up the coated side of the paper with a pencil, so you can tell which side to print on.

Making contact prints

Once dry the individual negatives were attached to a thick 10x8 plate of clean, unscratched plate glass. The importance of a weighty sheet of glass is that it provides sufficient pressure to keep the negative in contact with the paper while the exposure is being made. A good alternative is to use a clean contact-printing frame (without film strip holders), which works by clamping the print paper and negatives together. As when making a simple contact print, simply lay your inkjet negative on top of your printing paper, ink side uppermost, then lay or clamp the glass on top. For these simple prints, the enlarger lens was stopped right down and exposure tests of 3 seconds were made on a sample strip of emulsion-coated paper. Unlike older liquid emulsions, the SE1 brand is pretty fast and requires a similar length of exposure to standard multigrade printing paper.

Judging the results

The process is not as complicated or time-consuming as it first seems and is an ideal way to prepare negatives for a range of very different outputs. The print has a unique quality, unlike that from a film original, perhaps the gritty and grainy texture reflects the inkjet printer's ability to spray fine particles of ink. Enhanced grain is achieved when images are output using the black ink only options, with less coarse images resulting from using the colour inkset to output. Permajet offers the OHP film product in boxes of ten sheets and while it is more expensive than your average quality inkjet paper, you can easily output several images onto a single A4 sheet at a time. The media is an ideal support for making a range of negatives for contact printing out onto cyanotype, salted paper and other vintage processes.

Personal journal

Photographers like Sarah Moon and Deborah Turbeville, use hand-crafted assembly techniques normally found in scrapbooks and journals to make their unique photographic images.

Hand finished

The ability to make inkjet prints at precisely the size you need and the ease with which you can assemble a montage in Photoshop, makes the scrapbook-look achievable in an inkjet book or a digital press photobook.

For projects that demand a more personal take on a subject, the journal format is really worth exploring. Layouts do not have to conform to the normal rules, so geometric grids, considered typography and exhibition-print quality can be put on the back burner.

Instead, scrapbook-style arrangements, handwriting and throwaway print style can really help to make the final piece look more precious, personalised and much less formal. A great way to make a wedding album, family history book or a very individual response to a brief.

Taro Tyson: unique photobook

Resurrection de Jeunesse, (front cover shown right) is a hand-made photobook by Taro Tyson, created with conventional silver prints, masking tape and handwritten elements.

The book is assembled like a journal, mixing vintage family photographs, found objects and an array of surreal situations, page details shown far right, surrounding the photographer's day-to-day life.

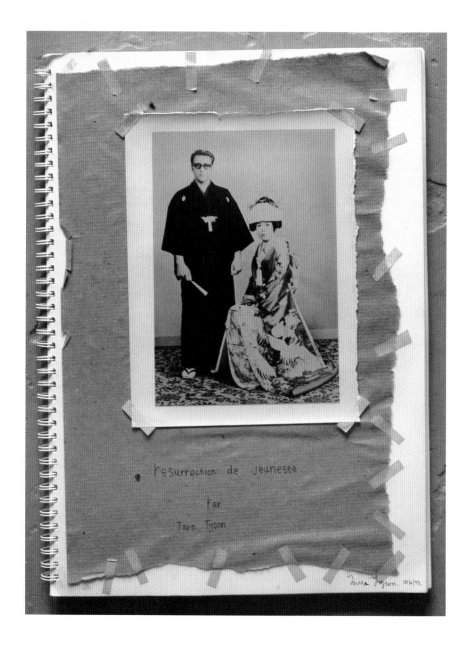

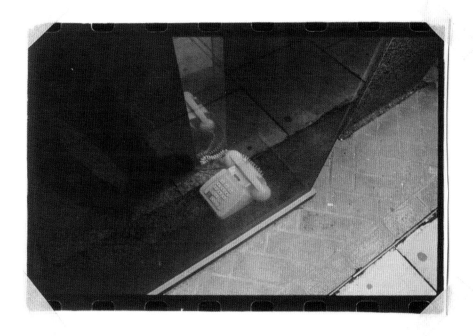

The book as a journey

There's no better way of recording your experience of a travelling through a new environment or in a challenging situation.

Navigating the paper highway

Unlike the Internet, most books are designed to be navigated in a linear manner; so, as author, you can really dictate how readers respond to your chosen subjects.

Picture content can be both paced and placed in a specific order, ensuring your message and meanings are carefully focused. You can also use the page sequence and the chapter structure of the book to subdivide your work, or provide a self-imposed limitation, such as using one (the best) image per spread, per day of your journey.

A 30-page book could be used to display a unique image taken each day over the period of a month, or thirty stops on a long journey.

Book as a journey precedents

Many photographers have used the theme of a journey as the core concept for a book-publishing project, most notably Robert Frank in *The Americans*. Published in the late 1950s, *The Americans* is not the record of an A to B journey, but of a meandering personal journey across the USA, chronicling the shifting social landscape during the gap between post-war and swinging sixties. There's no map provided, of course, but cumulatively the images provide an unprecedented insight.

Other examples of the use of a journey as a theme for a photographic project are Henri-Cartier Bresson's travels to China and India, both sophisticated examples of the photobook-as-record format.

Kimberley Haggis: M56 A Journey

This photobook takes the sequential nature of a book and uses it to describe a physical journey along a busy motorway. The images were created using a slow shutter speed and were shot from inside a moving car. The raw images contained plenty of abstract shapes and feeling of movement, which were further enhanced by editing in Photoshop.

In addition, the facing pages of the double page spreads are designed to bleed into each other, allowing some lines and colours to jump across the spine into the opposing page.

Weblink

www.blurb.com/user/kimberley3

Found photo-objects

Mass-produced imagery can evoke even more curiosity and interest when brought together by the vision of an individual collector. Such assemblages make excellent photobooks, too.

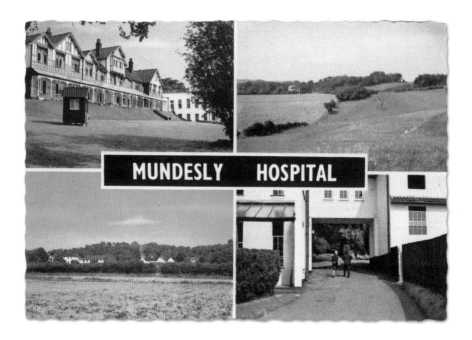

Stars on the Beach

A curious collection of discarded Italian lottery cards, shown above and right, has been gathered into a fascinating book by artist Loren Minnick. The lottery cards feature portraits of actresses and celebrities and are accompanied by suggested numbers as tokens of good luck. Some cards display scraps of handwriting, perhaps belonging to the last-known owner.

The cards were found in telephone boxes, railway stations and elsewhere and provide an intriguing insight into a nation's obsession with stardom, superstition and and religious iconography.

Stars on the Beach
www.blurb.com/user/minnickl

Photocards

Lurking in every postcard dealer's boxes are hidden gems of representation. Back in the nineteenth century, many calling cards and postcards were actually made with photographic paper, rather than the mass-produced lithographic prints we buy today.

Even major nineteeth-century photographers such as Camille Silvy and Henry Peach Robinson produced commercial portraits, prints of which are still being unearthed today at car boot sales and postcard dealers.

Postcards

Postcards not only tell us how we like to represent valued aspects of our physical environment, but also how our tastes and desires change.

The boom in low-cost commercial colour printing in the 1950s and 60s, revealed an entirely different way of picturing the world we live in.

Historic, quirky and surreal (see above) subjects can be found everywhere and there are many great collections of obscure postcards waiting to be collected and published in a photobook.

VERITA O FANTASIA?

Medusa

SE SONO ROSE, FIORIRANNO

TENDERE IL FUOCO

RAFFINATEEZZA

FORTUNE, REGALI CIELO-SOPPORTATI

la violenza della creazione

IN DREAMS BEGIN RESPONSIBILITY

Sette bellezze del la terra

IN GIORNO NEL TEMPO ORDINARIO

ANGELO DI MISERICORDIA

Instant prints

Peel-apart Polaroid and SX-70 prints can be made into unique photobooks, which are even better if they use vintage prints from your own archive.

Scanning originals

Instant prints are easily acquired and made ready for a book project using any mid-price flatbed scanner. Start by setting the scanner capture resolution, as shown above, at 600 ppi, as this will record as much detail as is present in the original.

Make a preview scan and ensure that all auto contrast and auto colour corrections are turned off, to preserve the print's original vintage colour and faded quality. Save as a TIFF and then open in Photoshop.

Photoshop preparation

Once opened in Photoshop, the first task is to cut the instant image away from the background and to preserve the shape of the print tab if desired.

Use the Pen tool to create a tight path around the print, then cut away the background. Next, consider applying the tiniest of drop shadows around the print tab, just enough to make it 'hover' above the page as if it were a physical print.

Delete the outline path (as this will interfere if placed in a DTP layout), flatten the layers, then save as a high quality JPEG or TIFF.

Inspirational photographers

One of the best books of instant prints is the excellent *Polaroids* by Walker Evans published by Scalo. Designed and produced by the Steidl team, renowned for their unique photobooks and artist's books, *Polariods* was published posthumously in 2002.

Most of the SX-70 prints, shot in the early 70s, show how Evans' obsession with reworking his public signage themes continued right up to his death in 1975. The book also has many contemporary colour works from the master of black and white documentary.

The book as a collection

Many photographers are obsessive collectors of things, both as physical objects and themes for long-term documentary studies.

Kerry Pitt-Hart: *I Spy*

This unusual photobook, shown above and right, has been made by artist Kerry Pitt-Hart and contains several examples of her unique still-life 'arrangements'.

The book presents different images of combinations of precious and throwaway objects, each like a visual riddle, with accompanying titles, clues or observations. Each page in the book has a different arrangement, shot in a very low-tech manner.

Still-life images like these benefit from the use of the pages of a book as a backdrop and provide interesting material for way a photobook.

I Spy

www.blurb.com/user/lushbella

Specimen hunting

The photobook is an ideal way to preserve and display the results of a photographic project concerned with recording collections of objects or images that have a comon theme. Perhaps taking their inspiration from early pioneer photographers who returned from long trips with bags of curios, many documentary photographers develop a passion for unusual or novel variations on a particular subject.

The scientific and non-creative use of photography has shown its value as a means of recording, cataloguing and preserving things. This archival aspect of the art has encouraged many creative photographers to work in a cool, detached way, seeking out and recording examples of things, people and places.

Photographer precedents

One of the greatest early collection-based books was made by German photographer August Sander. In *Antlitz der Zeit* (Face of Our Time), Sander made portrait photographs of German people in different social, economic, occupational and ethnic categories and compiled his images like a reference book. The book was a precursor to Sander's gigantic portrait project, *Man in the Twentieth Century*.

Later in the twentieth century, husband-and-wife team Bernd and Hilla Becher, spent years visually cataloguing different industrial and municipal installations such as water towers, over time creating a vast body of work. Seen together, the Becher's pictures are a unique vision of curiously beautiful buildings.

Tiny Pearls

Can you name the insect these wings belonged to?

The Queen's Cologne

This was inspired by the perfume label of a fragrance I once wore. Can you guess which one?

Follow me II

Write a short story based on the objects in this photograph. If it pleases you, send your story to the address found at the end of this book.

Morpho Pins

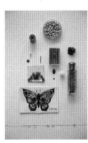

The butterfly postcard has a wheel at the bottom. When you turn it, the colors of the wings change.

Mrs. Gainsborough

Like a bowerbird, I went searching for all things blue, and this is what I found. What blue objects do you have surrounding you?

Without You I Am Nothing

The label reads "Rien n'a de sens sans toi". This is French for "Without You I am Nothing."

Inkjet transfer book

By-passing the normal quality standards of inkjet printing, the simple transfer print can transform your digital files into unique one-off prints.

Transfer printing essentials

Many transfer printing processes have been used in photography since the birth of the medium in the 1840s, including carbon tissue, dye transfer and Polariod transfers. The common thread linking these very different ways of working, is the creation of unique and unrepeatable prints. The term transfer printing describes the making of an ink-loaded donor sheet, which is subsequently pressed into contact with a receiving sheet, to make a final print.

Printer issues

In order to make inkjet transfer prints, you need to use a printer that does not incorporate a pizza wheel paper ejector. These tiny metal wheels mark your donor sheets as they pass out through the printer, spoiling your hard-won, inky starting point. Many good quality A3 printers, such as my own Epson Stylus Photo 2100, use a pizza wheel and were useless for the project. Better printers not only avoid this type of paper transport mechanism, but also have software controls for changing the platen width and ejection method, so your donor sheets can pass through the device, soaked with wet ink but not in contact with any wheels or guiding pins.

Donor media

Getting the right kind of media is key to this process, and the best to use is a type of plastic paper that holds ink droplets without puddling, and, most importantly, doesn't dry. The best results were gained by using the wrong side of the Epson Transparency Media. This media is glossy white and shiny on one side, with a matt, coated reverse side designed to accept the ink in normal, everyday use. The good news about using this kind of media as donor material is that it can be re-used, providing any excessive ink is wiped clean after each impression is taken. The media is available in A4 and can be used in most printers through the standard paper tray, rather than as a special sheet load.

Receiving paper

Many different types of paper media can be used to capture detail and saturated colour to varying degrees. Copier paper, cream cartridge paper and textured writing paper can all be used, together with Harman's Gloss FB paper and Hahnemuhle's Fine Art Rag Duo. Non-traditional inkjet media will suck the ink away from the donor media at different rates depending on the surface texture, creating lower-contrast results overall.

Without doubt, the best results are achieved on smooth-textured, purpose-made inkjet paper, but other surfaces are well worth experimenting with. After the print emerges from your desktop inkjet, it's essential to place the donor paper in contact with your receiving paper as soon as possible before the ink starts to dry. Good results were also achieved with the unconventional media when it was wetted and blotted prior to printing. This method is especially useful if your donor paper starts to absorb the ink before you can get it into contact. Damp paper works best, but excessively wet paper will make the ink bleed when it comes into contact, thereby ruining the recognisable shapes and details in your image.

File preparation

With transfer prints, unlike most other ways of making inkjet prints, the actual file-preparation stage is much less crucial than control over printer settings. Both the tonal range and colour saturation of the final print dropped remarkably after printing. But rather than trying to compensate for this, it's important to accept the unconventional nature of the final print. The only issue worth considering is the actual output size of your image. Aim to print out an image that is no wider than the roller you'll use to make the transfer, or you'll end up with irregular vertical lines appearing on your prints.

Printer software controls

How you manipulate the printer software settings is key to the success of this technique. The overriding issue here is to spray enough ink onto the donor paper to ensure image details are present; but not too much, otherwise inky details will mix and merge into each other. It's best to use the lower end of the printer resolution settings, such as 360 dpi or 720 dpi, as this will prevent too many ink dots from being loaded onto the sheet.

Print at anything higher and most of your image details will blur into each other. Experiment, too, with media settings, using Plain Paper, Matt Paper and any setting other than Photo Glossy paper and Film options. It's important to experiment with these settings to get the kind of result you are after and it's a surprise to see little difference between a transfer prints sprayed at 720 dpi and one at 360 dpi. In addition to the resolution and media type, ensure that you deselect both Quality and Fine Detail settings in your printer software, choosing

High Speed options. This ensures your donor media literally flies out of the printer into your hands before the ink has a chance to think about drying. Despite the crude output settings, you'll be surprised just how much detail appears on your final print.

Making the print

The way the donor media is handled between the printer and your receiving paper is critical, too. Aim to keep the donor media flat, or the wet ink will start to move around and create cracks between connected areas.

Alternatively, simply accept that this last lap will impart as much character to your print as your careful software editing. Ensure that you have got some padding paper, such as a newspaper, underneath your receiving paper, so no surface bumps from your worktable affect the passage of the roller and make an unwanted mark on your print.

Once the two sheets have been pressed together, help the ink to migrate by using a firm rubber roller, the type used for inking up artists' lino- or woodcuts. The amount of pressure you apply to the roller needs to be firm, but not crushing, as this will squeegee the ink into an irregular shape and destroy your sharpness.

Experiment with your hand pressure until you can roll off the ink in two or three separate passes. With most absorbent receiving paper, your donor paper won't move between rollings and cause mis-registration, so you can be relatively relaxed rather than white-knuckled during the rolling out. When you think your ink has transferred, gently lift up a corner of your donor paper and take a look

underneath. If your donor paper still contains ink, then replace the corner and keep on rolling. It should be possible to roll most of the ink off the donor paper so it's pretty much clean. To finish, peel the donor paper off entirely to reveal the finished print underneath. Leave this to dry on a flat surface for thirty minutes or so, and wipe the remaining ink off your donor sheet with a damp cloth ready to re-use.

Working with a brush

If you want to intervene even more, it is possible to modify the image on the donor paper with a brush before making your transfer print. After it emerges from the printer, take a soft-haired brush and run it along the perimeter of your image to create a random smudgy edge. When printed this creates a much more interesting border than a sharp-edged rectangle. When brushing over a plastic donor media, the ink doesn't blend or make a wash like watercolour paint, as you'd expect, but moves around in mercury-like blobs, which increase in size as you brush. Aim to work lightly and don't attempt to draw anything specific. You can even wet your brush to dilute the ink slightly and make the colour fade out at the edges.

Results and print characteristics

Once produced, the resulting prints have all the traditional properties of a Polaroid transfer print: showing a wonderful loss of sharpness and contrast, plus the kind of random pattern cracklelure that makes the process worth doing. The black ink rarely migrates as much as the other colours, leaving the prints with a fresco-like chalkiness.

References and resources

----> Photobook printers

----> Jargon Buster

----> Index

----> Contacts and credits

Photobook printers

Check out the range of products, prices and free design software at the websites of these established photobook printers.

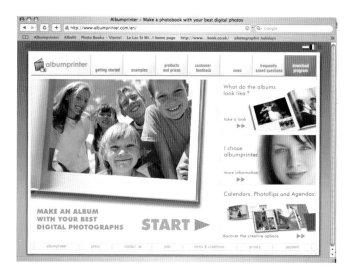

www.albumprinter.co.uk

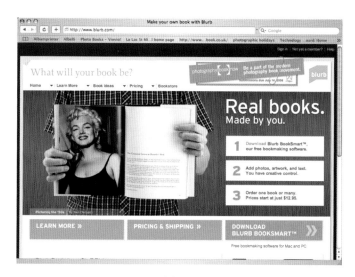

www.blurb.com

www.bobbooks.co.uk

www.cewe-photobook.co.uk

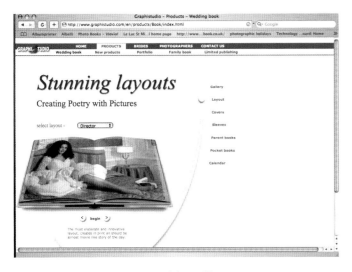

www.graphistudio.com

www.lulu.com

www.myphotobook.co.uk

www.photobox.co.uk

www.viovio.com

www.yophoto.co.uk

www.booksmartstudio.com

www.bookbinding-supplies.co.uk

Jargon buster

Artifacts
By-products of digital processing, like noise, which degrade image quality.

Aliasing
Square pixels describe curved shapes badly and look 'jaggy' close-up . Anti-aliasing filters and software lessen the effects of this process by reducing contrast at the edges.

Batch processing
Using a special type of macro or Action file, batch processing applies a sequence of preset commands to a folder of images automatically.

Bit
A bit is the smallest unit of data representing on or off, 0 or 1, or black or white.

Bitmap image mode
Bitmap image mode can display only two colours, black and white, and is the best mode to save line art scans. Bitmap images have a tiny file size.

Bitmap image
A bitmap is another term for a pixel-based image arranged in a chessboard-like grid.

Byte
Eight bits make a byte in the binary system. A single byte can describe 0–255 states, colours or tones.

CCD
The charged coupled device is the light-sensitive 'eye' of a scanner and 'film' in a digital camera.

Clipping
Clipping occurs when image tone close to highlight and shadow is converted to pure white and black during scanning. Loss of detail will occur.

CMYK colour mode
Cyan, magenta, yellow and black (called K to prevent confusion with blue) is a colour mode used for litho reproduction.

Colour depth
This describes the size of colour palette used to create a digital image, e.g. millions of colours.

Colour management
This describes the process by which consistent colours are maintained when image files are transferred across different hardware and software devices.

Colour workspace
RGB, CMYK and LAB are all different colour spaces with their own unique palette and limitations.

Compression
Without reducing the pixel dimensions of an image, compression routines devise compromise colour recipes for groups of pixels, rather than individual ones.

Contract proof
A process used in commercial printing when a document is first tested for colour accuracy. Quality assured by ISO standard.

Curves
Curves is a versatile tool for adjusting contrast, colour and brightness.

Diffusion dithering
A dithering technique allocates randomly arranged ink droplets, rather than a grid, to create an illusion of continuous colour.

Dithering
A method of simulating complex colours or tones of grey using few colour ingredients. Close together, dots of ink can give the illusion of new colour.

Dropper tools
Pipette-like icons that allow the user to define tonal limits like highlight and shadows by directly clicking on image areas.

Dye sublimation
A kind of digital printer that uses a CMYK pigment-impregnated ribbon to press colour onto special receiving paper.

Dot pitch
A measure of the fineness of a monitor's shadow mask. The smaller the value, the sharper the display.

Dot gain

A term used in commercial printing to describe the darkening of a halftone effect
due to paper absorbancy.

DPI (scanner)

A measure of the resolution of a scanner. The higher the number, the more data you create.

DPI (printer)

Printer DPI is an indication of the number of separate ink droplets deposited by a printer. The higher the number, the more photo-real results will look.

DTP

Desktop Publishing describes the use of an application such as InDesign or QuarkXpress to create documents for publication.

Duotone

A duotone image is constructed from two different colour channels chosen from the Colour Picker Duotone and can be used to apply a tone to an image.

Driver

A small software application that instructs a computer how to operate an external peripheral like a printer or scanner. Drivers are frequently updated but are usually available for free download from the manufacturer's website.

Dynamic range

A measure of the brightness range in photographic materials and digital sensing devices. The higher the number, the greater the range.

EPS

Encapsulated Postscript is a standard format for an image or whole page layout, allowing it to be used in a range of applications.

File extension

The three or four letter/number code that appears at the end of a document name, preceded by a full stop, e.g. landscape.tif. Extensions enable applications to identify file formats and enable cross-platform file transfer.

FireWire

A fast data transfer system used on recent computers, especially for digital video and high-resolution image files. Also known as IEEE1394.

Flattened artwork

A press-ready graphics file which has had it's layers and masks removed before being supplied to a commercial printer.

Font

A font is a set of characters including letters, numbers and symbols that have been designed using a vector drawing application. As such individual characters can be resized without any loss in quality or change in proportion.

Four colour black and white

A process used in commercial printing to achieve a tonally richer version of a monochrome image using all four CMYK ink colours rather than just black.

Gamma

The contrast of the midtone areas in a digital image.

Gamut

A description of the extent of a colour palette used for the creation, display or output of a digital image.

GIF

Graphics Interchange Format is a low-grade image file for monitor and network use, with a small file size due to a reduced palette of 256 colours or less.

Grayscale

Grayscale mode is used to save black and white images. There are 256 steps from black to white in a grayscale image, just enough to prevent banding appearing to the human eye.

Halftone

An image constructed from a grid of dots of different sizes to simulate continuous tone or colour. Used in magazine and newspaper publishing.

Highlight

The brightest part of an image, represented by 255 on the 0–255 scale.

Histogram

A graph that displays the range of tones in a digital image as a series of vertical columns.

ICC

The International Colour Consortium was founded by the major manufacturers in order to develop colour standards and cross-platform systems.

Indigo press

A digital printing press made by HP, which uses liquid inks without the need for printing plates.

Inkjet

An output device which sprays ink droplets of varying size onto a wide range of media.

ISO speed

Photographic film and digital sensors are graded by their sensitivity to light. This is sometimes called film speed or ISO speed.

Interpolation

Enlarging a digital image by adding new pixels between existing ones.

JPEG

A compression routine used to reduce large data files for easier transportation or storage. Leads to a reduction in image quality if files are repeatedly opened and re-saved.

Kilobyte (K or Kb)

1024 bytes of digital information

Layered image

A kind of image file, such as the Photoshop file, where separate image elements such as text and image can be arranged above and below each other, like a stack of cards.

Layer blending

A function of Photoshop layers, allowing a user to merge adjoining layers based on transparency, colour and a wide range of non-photographic effects.

Layer opacity

The visible 'strength' of a Photoshop layer can be modified on a 0–100% scale. As this value drops, the layer becomes semi-transparent and the underlying layer starts to show through.

Leading

The vertical distance between two lines of type on a page.

Levels

A set of tools for controlling image brightness found in Photoshop. Levels can be used for setting highlight and shadow points.

Line art

A type of original artwork in one colour or tone only, such as typescript or pencil drawings.

Megapixel

Megapixel is a measurement of how many pixels a digital camera can make. An image measuring 1800 x 1200 pixels contains 2.1 million pixels (1800 x 1200=2.1 million), or 2.1 Megapixels.

Megabyte (Mb)

1024 kilobytes of digital information. Most digital images are measured in Mb.

Noise

Like grain in traditional photographic film, noise is an inevitable by-product of shooting with a high ISO setting. If too little light passes onto the CCD sensor, brightly coloured pixels are made by mistake in the shadow areas.

Optical resolution

Also called true resolution, this is a measure of the hardware capability, excluding any enhancements made by software trickery or interpolation.

Output profile

A tiny file used to accurately translate colours from a desktop file to a specific printer/ ink and paper combination.

Pantone

The Pantone colour library is an internationally established system for describing colour with pin-number-like codes. Used in the lithographic printing industry for mixing colour by the relative weights of the four process colour inks.

Path

A path is a vector-based outline used in Photoshop for creating precise cut-outs. As no pixel data is involved, paths add a tiny amount to the file size and can be converted into Selections.

PCI Slot

A Peripheral Component Interface Slot is an expansion bay in a computer used for upgrading or adding extra connecting ports or performance-enhancing cards.

PDF

Portable Document Format is a universal file format used to deliver press-ready artwork to a printer.

Pigment inks

A more lightfast inkset for inkjet printers, usually with a smaller colour gamut than dye-based inksets. Used for producing prints for sale.

Pixel

Taken from the words Picture Element, a pixel is the building block of a digital image, like a single tile in a mosaic. Pixels are generally square in shape.

Process colours

The term used to describe the four standard ink colours, cyan, magenta, yellow and black, used in lithographic printing.

Profile
The colour-reproduction characteristics of an input or output device. Profiles are used by colour-management software such as ColorSync to maintain colour accuracy when moving images across computers and input/output devices.

Proof
A proof is a single print-off produced in advance of the proper print run. This is made by a commercial printer and presented to the client for sign-off.

Quadtone
A quadtone image is constructed from four different colour channels, chosen from the Colour Picker or custom colour libraries like Pantone.

RAW
The term RAW describes an image file that has been captured and stored in an unprocessed state. RAW files must be opened in special applications such as Lightroom before editing.

RAM
Random Access Memory is the part of a computer that holds your data during work in progress. Computers with little RAM will process images slowly as data is written to the hard drive, which is slower to respond.

RIP
A Raster Image Processor is used as an alternative printer driver when sharing a printer on a network or outputting jobs simultaneously on a large-format printer. RIP's can be both hardware and software.

Resolution
The term resolution is used to describe several overlapping things. In general, high-resolution images are used for printing out and have millions of pixels made from a palette of millions of colours. Low-resolution images have fewer pixels and are only suitable for computer monitor display.

RGB image mode
Red, Green and Blue mode is used for displaying colour images on a monitor. Each separate colour has its own channel of 256 steps and pixel colour is derived from a mixture of these three ingredients.

Selection
A fenced-off area created in an imaging application like Photoshop which limits the effects of processing or manipulation.

Shadow
The darkest part of an image, represented by 0 on the 0–255 scale.

Sharpening
A processing filter which increases contrast between pixels to give the impression of greater image sharpness.

Soft-proofing
The process by which you can predict the likely outcome of a print by simulating the end result on your monitor. Requries the use of an output profile.

Spot colour
Used in commercial printing to define a fifth i.e non CMYK ink colour. Mostly used to achieve an out of gamut colour or special effect.

TIFF
Tagged Image File Format is the most common cross-platform image type used in the industry. A compressed variation exists which is less compatible with DTP applications.

Tritone
A tritone image is constructed from three different colour channels, chosen from the Colour Picker or custom colour libraries like Pantone.

Unsharp Mask (USM)
This is the most sophisticated sharpening filter, found in many applications. Recent versions of Photoshop offer an enhanced kind of USM called Smart Sharpen.

USB
Universal Serial Bus is a recent type of connector which allows easier set-up of peripheral devices.

Varnish
A transparent ink layer applied to a book cover or on top of an image to enhance the dynamic range.

White balance
Digital cameras and camcorders have a white-balance control to prevent unwanted colour casts. Unlike photographic colour film, which is adversely affected by fluorescent and domestic lights, digital cameras can create colour-corrected pixels without using special filters.

Index

A

Adobe Acrobat 76-77

Adobe ACE 49

Adobe Bridge 48, 66

Adobe Creative Suite 73, 74

Adobe Gamma 50

Adobe InDesign

 colour management 73

 document preview 73

 exporting as JPEG 73

 pre-flight checks 107

 working with 74-75

Adobe RGB (1998) 46, 49

Adobe Photoshop

 adjustment layers 52, 56, 122

 blending mode 118

 burning and dodging 98

 color picker 114

 curves 57

 clone stamp tool 98

 color balance 59

 contact sheet 88

 convert to profile 49

 duotones 44, 60-61

 eyedropper 114

 grayscale mode 60

 hue/saturation 98

 image size dialog 62-63

 layers 52, 72

 levels 56

 masks 56, 100

 paths 100, 136

 rendering intent 49

 smart filters and layers 52, 122

 soft proof 46-47, 50-51, 56

 type effects 72

 variations 58

Adobe Photoshop Express 54-55

Adobe Photoshop Lightroom

 library function 66-67

 non-destructive processing 52-53

Apple Mac 50

artist statement 36

B

Ballan, Josh 115

B3 12-13, 48, 50

Blurb.com 12-13, 54, 88, 108

Bobbooks.co.uk 63, 90, 95

bone folder 124

BookSmart software 12-13, 66, 68-67, 108

Booksmart Studio 22

Book

 bespoke 22-23

 binding by hand 124-125

 binding options 20-21

 blog 88-89

 cover coatings 18-19

 cover types 18-19

 formats 14-15, 86

 hardback 16

 portfolio 40

 production costs 24-25

 running order 132

 selling 24-25

 small format 90

 softback 16

Burren, The 29

C

calibration 50

Camera Raw plug-in 48, 53

captions 86, 110-111

Carlisle, T Scott 84-85, 109

Case Histories 32-33

Clarkson, Pamela 106

clip art templates 92

Collins, William 109

colour adjustment 58-59

colour balance 58

colour space 46-47, 78

colour space workflow 48-49

colour management 46-47

composition 82

contrast adjustment 56-57

CMYK 46, 48, 50, 60

contact print 34

cropping 82

D

daguerreotype	116
Daniel, Michal	88-89
digital negatives	126
digital press	10, 44
profiles for	50
digital scrapbooking	96-97
documentary photography	30, 86-87
dot gain	44
dot screen	44-45
double page spread	82-83

E

e-book	14, 24
e-book reader	25
endpapers	112-113, 125
EPS file format	61, 116
exhibition catalogue	36-37

F

Facebook	54
family album	90-91
family history	96-97
flat contrast	57
Flickr	54, 88
fluorescent light	59
file management	66-67
fonts	
families of	106, 100
sans-serif	106
seriffed	106

script	106, 110
style sheets	106
found objects	134
four colour black and white	60
full-bleed	84-85, 92

G

garden photography	30
Genuine Fractals	84
graphic panels	116-117
guillotine	20, 84, 123

H

Haggis, Kimberley	132
Hannemuehle paper	122, 140
hardware profiling kit	50
high key	57
Holga	34
holiday album	92-93
HP Indigo	10-11, 47, 56

I

ICC profile	44-45, 50
inks	
Indichrome	44
pigment	122
process colours	44-45, 60
Pantone colours	44, 60-61
tints	114
solids	114
inkjet books	122

inkjet transfer	138-141
Innova paper	122
image wrap cover	92
imposition	123
independent travel	38-39
Indichrome	44
ISBN	14
iStockphoto	100, 116

J

JPEG file format	49, 54, 56
journal	38

K

Kaufman, Jessica	40, 109

L

laminated covers	108
landscape	28
'Late' Photography	32
lines per inch	44
London Independent Photography	25
low key	57
Lulu.com	14-15

M

marbling	113
Mars, Robert	36-37, 109
Minnick, Loren	134-135
monitor calibration	50

N

Nikon

 Adobe RGB(1998) 47

 D3 SLR 49

non-destructive editing 52-53

O

O'Boyle, Shaun 86-87, 109

P

Pantone inks 44

paper

 coating with emulsion 128

 grain direction 123

 handmade 119

 imposition 123

 sewing into sections 124

 scoring and folding 124

 trimming 123

PayPal 24

Permajet 126

PDF 10, 12, 14, 25, 74, 76-77, 107

PDF distiller 76

perfect binding 20

PhotoBook Proofer 78-79

Photobox 92

photo covers 108-109

photo emulsion 126-127

PhotoBucket 54

photocorners 96

PhotoFrame plug-in 72

photo reproduction 42

Picasa 54, 88

Pitt-Hart, Kerry 109, 138-139

pixels per inch (ppi) 44

placeholder 82

Polaroid 100-101, 136-137, 140

pre-flight checks 74, 103

printer software 122, 126, 142

printing on demand 10

profiles

 digital press 50-51

 generic 51

 ICC 44-45, 50

 installing 51

 printing with 122

ProPhoto 46

Q

QuarkXpress 74, 107

R

raster Image Processor (RIP) 10

RAW file format 48-49, 52-53

resolution 44, 48, 62-63

resizing 62-63

RGB 46-47, 49, 50

Rozen, Andrei 38

S

salt print 118

scaling down images 62

scaling up images 62

scanning source images 98-99, 136

soft-proofing 44

slurping 54, 66

sRGB 46, 48

style sheets 107

T

textured papers 118-119

TIFF file format 49

time-limited projects 30

tungsten lighting 58

Turner, Luke 109

Tyson, Taro 130-131

U

urban Spaces 34-35

Unibind 21

V

vector images 116-117

vintage mounts 98-99

W

warmtone images 115

wedding album 94-95

Windows 50

Word documents 76

Contacts and credits

Further tuition

Tim Daly also runs Photocollege, the online learning centre for photography and photo-imaging.

Photocollege provides online tuition for a wide range of photographers and creative industries professionals on topics including colour management, digital printing, Lightroom and Photoshop.

Visit the website on:
www.photocollege.co.uk

Contact the author by email on:
timdaly@photocollege.co.uk

Friends and supporters

The author would like to thank the following family and friends for their invaluable help in the research and production of this book:

Nina Daly for book design.

Piers Burnett and Eddie Ephraums at Argentum.

Chris Dickie, Editor of *Ag: The Journal of Photographic Art & Practice*.

Philip Andrews, editor of *Better Photoshop Techniques* (AUS).

Suppliers

The author would also like to thank the following suppliers for their advice and support in the research for this book:

Adobe
Adobe Photoshop CS3 and Lightroom software applications.
www.adobe.com

www.blurb.com

YoPhoto.co.uk and Bobbooks.co.uk

Workshops

Tim Daly also runs creative printing and photobook workshops for the following:

The University of Chester
see www.timdaly.com

The Royal Photographic Society
www.rps.org

London Independent Photographers
www.londonphotography.org.uk

The West of Ireland Photography Study Centre, Mayo, Ireland.
www.glendacolquhounphotography.com

Rocky Mountain School of Photography, Montana, US
www.rmsp.com

Photobooks by Tim Daly

Tim Daly: unique photobooks
Preview and purchase limited edition
photobooks by Tim Daly by visiting his
online bookstore at:

www.blurb.com/user/timdaly

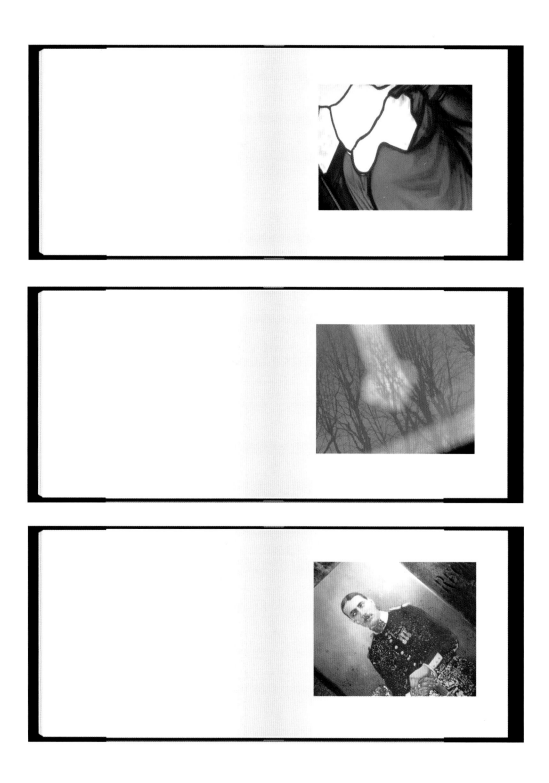

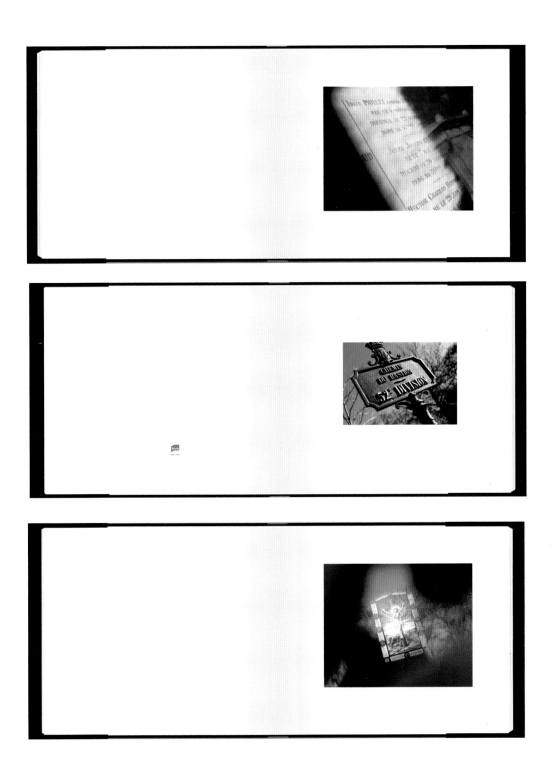

ALL-WEATHER *ICONS*